Westfield Middle School
Media Center

W9-AYF-420

Mary Cassatt

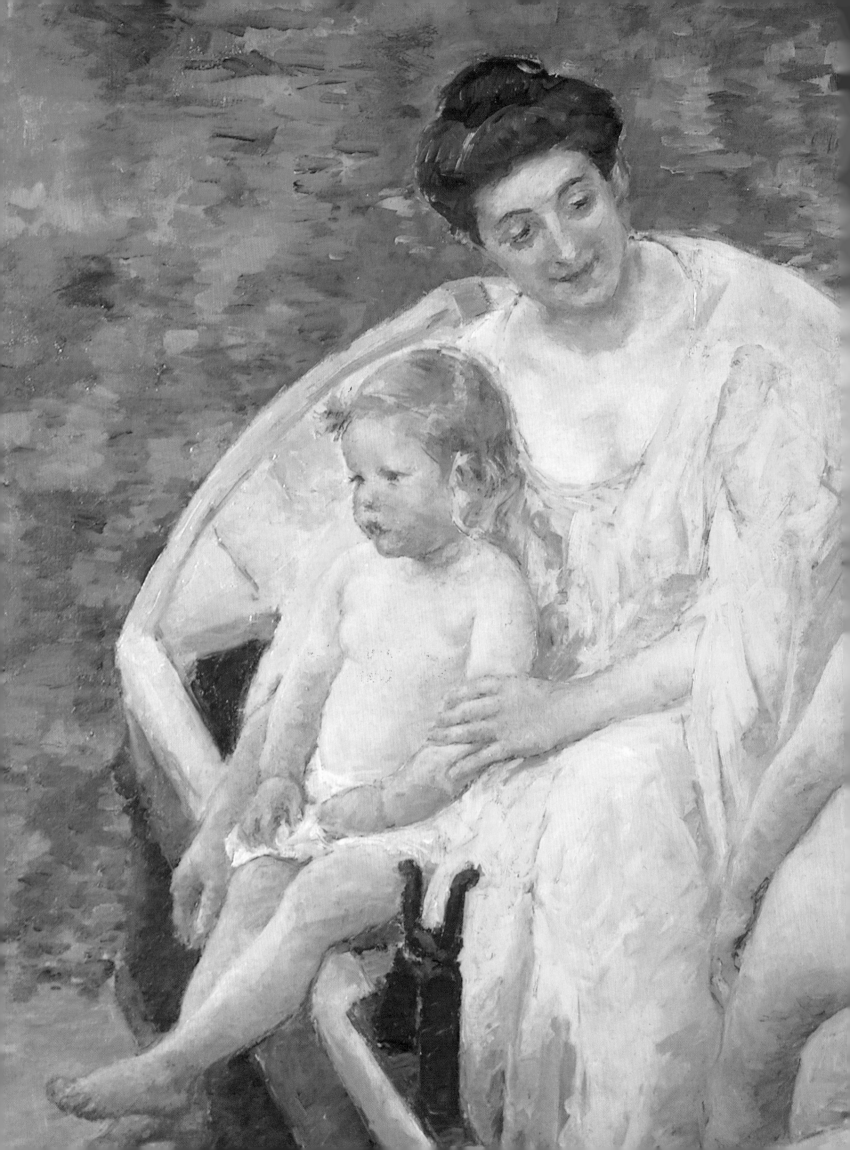

Westfield Middle School
Media Center

Mary
Cassatt

Trewin Copplestone

GRAMERCY

Westfield Middle School

402002

Copplestone, Trewin 759.13 COP
Mary Cassatt

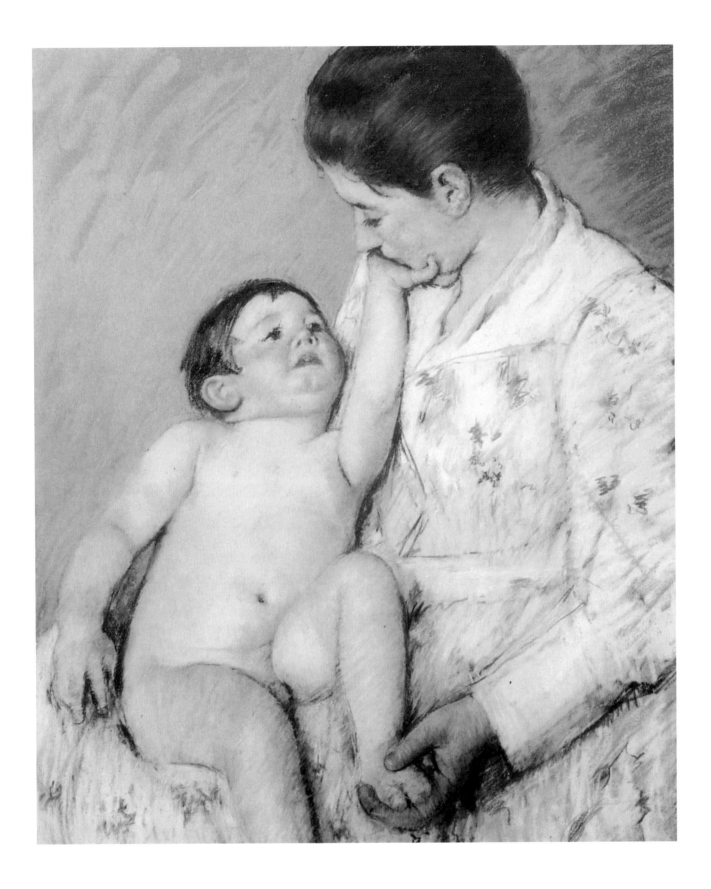

Copyright © 1998 Regency House Publishing Limited

No part of this book may be reproduced or transmitted in any form or by any means electronic or mechanical including photocopying, recording, or by any information storage and retrieval system, without permission in writing from the publisher.

This 1998 edition is published by Gramercy Books, a division of Random House Value Publishing, Inc., 201 East 50th Street, New York, NY 10022
Gramercy Books and colophon are trademarks of Random House Value Publishing, Inc.

Random House New York • Toronto •London • Sydney • Auckland
http: / / www.randomhouse.com/

Printed in Italy

ISBN 0-517-16065-X

10 9 8 7 6 5 4 3 2 1

List of Plates

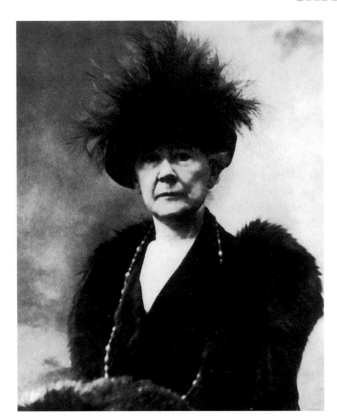

PLATE 1
Photograph of Mary Cassatt (1914)
This photograph was taken when Cassatt was 70 and reveals her as the grande dame *she believed herself to be.*

Mary Stevenson Cassatt, an American painter and printmaker, was born in Allegheny City, near Pittsburgh, Pennsylvania in May 1844 and died in 1926 at the Château Beaufresne, near Beauvais in northern France in the same year that Claude Monet himself died. The story of the years which led from a provincial American childhood to fame as a member of the most admired art movement of the later years of the 19th century is of considerable interest.

It is worth noting that, until recently, women have rarely found a place in the history of professional art. It is important to make this distinction between professional and amateur painters because it was usual for young ladies to be able to count watercolour painting among their accomplishments, along with playing a musical instrument, singing and, less commonly, writing. These were regarded as the proper pursuits of educated and privileged women but were not seen in the same light as the work of professional male painters who since the liberation of the Renaissance had been accepted into the higher levels of culture and society. It therefore required more than determination on the part of young socialite women to break into this closed profession. Those who succeeded could almost be counted on the fingers of one hand until the onset of the dramatic cultural changes which occurred following the French Revolution at the beginning of the 19th century. It took over 100 years for the nominal

emancipation of women but the continuing concerns in respect of women's place in society indicate that the process is not yet complete. And this is in the so-called free democracies; parts of the rest of the world still appear to be resisting changes to historical and traditional patterns.

Even in the later 19th century it was still a pioneering act to wish to become a professional artist and few succeeded in freeing themselves of the allocated role of wife and mother. It is important to recognize the determination and ability necessary to achieve the level of independence and acceptance required to achieve this.

Mary Cassatt was the second daughter of an upper-middle-class family. With a stockbroker father and an extremely well educated mother, well read and fluent in French, Mary had the sort of early upbringing that would have made her eminently suited to the very activities and programme outlined above: the privileged life of wife and mother, cossetted by servants and with time on her hands. This anticipated course of events was interrupted by her father's decision to move to Paris in 1851 when Mary was seven.

Shortly after their arrival, dramatic events occurred which were to change not only the political and cultural scene in France but the physical face of Paris. Following the French Revolution and the First Empire of Napoleon, the Bourbon dynasty was returned in the form of Louis XVIII and, on his death, Charles X. Revolution against

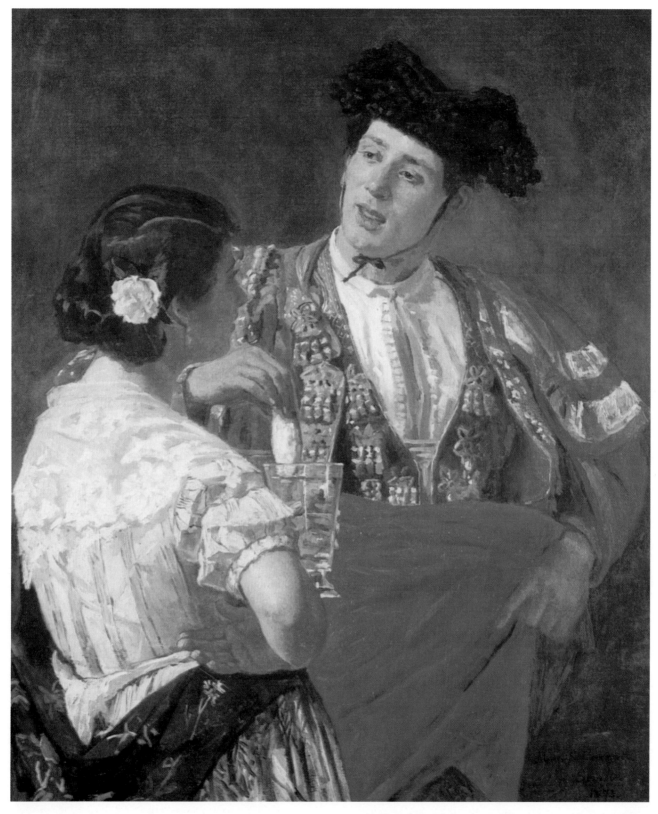

PLATE 2
Offering the *Panal* to the Toreador (1873)
Oil on canvas, 39$\frac{1}{2}$ x 33$\frac{1}{2}$ inches (100.3 x 85cm)

*Painted during Cassatt's period in Spain, this is a typically
Victorian painting executed in the traditional tonal technique which
gives little evidence of her later achievements although it is revealing*
*of her effective academic training and shows the influence of both
Murillo and Manet.*

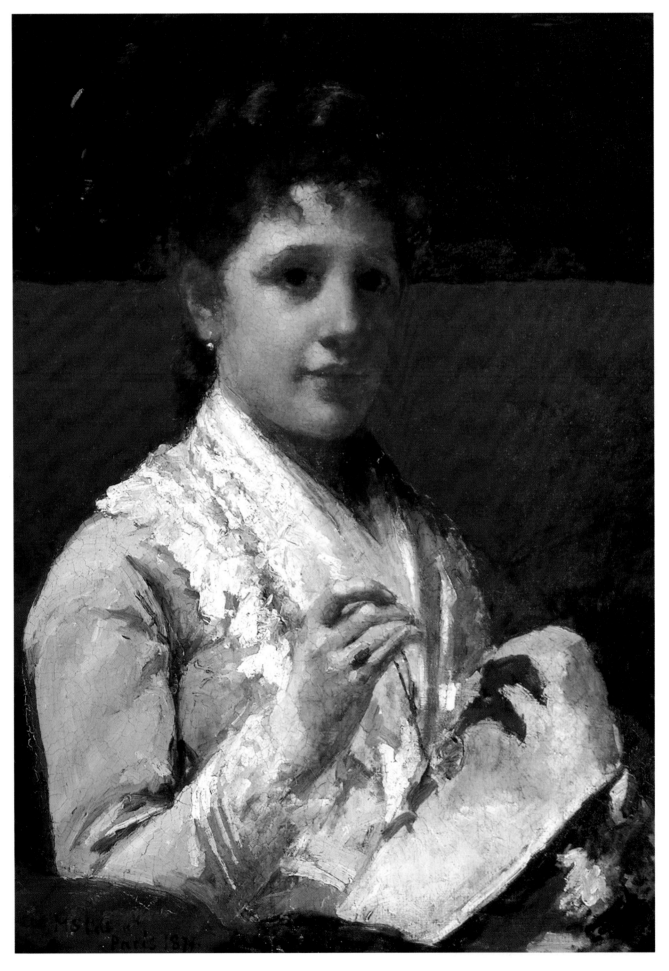

PLATE 3
Mary Ellison Embroidering (1877)
Oil on canvas, 29¼ x 23½ inches (74.2 x 59.6cm)

This portrait of an acquaintance of Cassatt's when she was in Paris and the subject of a few studies, is shown here engaged in the kind of activity that was acceptable for young ladies of good breeding. Although Cassatt did not profess to be a portrait-painter and did not generally accept commissions even of people she knew, her technical facility enabled her to produce images of considerable authority when she chose to undertake them. As in this painting, her subjects are usually engaged in some useful activity of importance in their lives. Mary Ellison looks up from her work at the painter as if engaged in conversation. Cassatt's technique is careful and delicate and her observation acute.

the inept political manoeuvring of Charles followed in 1830 and he was replaced by the 'citizen king', Louis Philippe who in turn was ousted at the age of 74 and fled to England in what has become known as the year of revolutions, 1848. He was replaced by Louis Napoleon, who was regarded by many as a nonentity but who carried the magic name of Napoleon, causing him to be elected as Prince President of the Second Republic. During the succeeding three years he worked assiduously and intelligently to consolidate his position, engineered a *coup d'état* in December 1851, and was translated into Napoleon III, creating the Second Empire which was formally introduced in December 1852.

It was not an auspicious time for the Cassatt family to have arrived in Paris. Troops were positioned throughout the city and had occupied the Chamber of Deputies, the seat of government. Hundreds of citizens were killed and as many as 30,000 were arrested or deported to Algeria, then a French colony. The French Revolution of 1789 was still remembered by the older citizens, a new imperialism was unsettling and undesirable and tension was mounting in an armed Paris. Although they had begun to settle in the city, the Cassatts moved to Germany where they remained until 1855 before returning to America. However, they visited Paris en route to visit the Exposition Internationale and Mary remained attracted to Paris despite the short time she spent there.

On their return to America they settled back into the familiar routine and Mary was expected to follow her traditional domestic role. But at the age of 16 she rebelled and, as might be anticipated, enrolled in the Pennsylvania Academy of Fine Arts against the wishes of her father. She came from such an affluent background of solid respectability, was indeed a young socialite, that her actions were all the more deplored by friends and acquaintances; but more importantly, she was to prove something of a problem to the Academy. She insisted on following the normal course undertaken by her male colleagues, declared that she intended to be a professional artist and persuaded the authorities to accept her in all subjects apart from studies of the male nude. At the time it was still assumed that the mere sight of the nude male was improper and dangerous for a female, and could potentially lead to immorality. As a female student, however, she was permitted to make drawings from plaster casts, usually of classical subjects. When one remembers that all too frequently in the 'Victorian' mid-century sculptures wore a fig leaf, prurience may well have been added to ignorance. The extent to which this affected Cassatt is problematical; but her work rarely includes male figures and when they do are portraits or small male children. Only three male portraits exist of any but her own family members, most of these taken from the family of the brother who was closest to her.

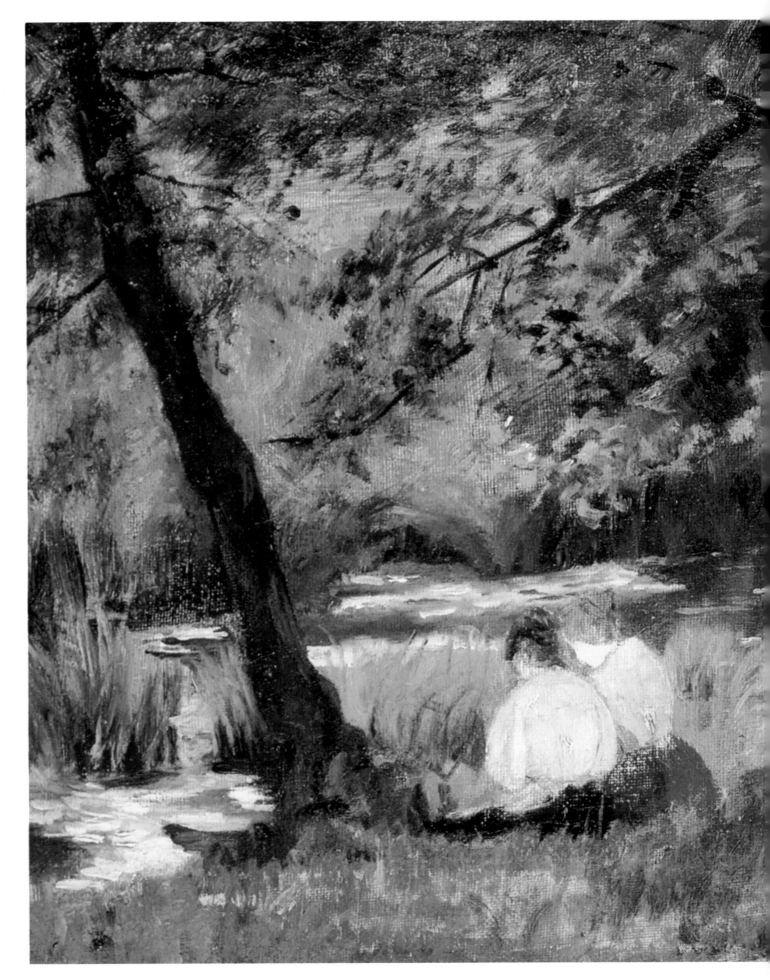

PLATE 4
Two Women Seated by a Woodland Stream
(c. 1869)
Oil on canvas, 9¹/₂ x 13 inches (24 x 33cm)

This study of two women sitting on the banks of a stream is rare as Cassatt treats landscape mainly as a background for her figures. It has a rather sketchy appearance which would suggest that it is unfinished.

It should be remembered that at this time Cassatt had not yet become involved with other young painters such as Manet, Degas and Monet, who was almost an exact contemporary and in fact died in the same year as Cassatt.

She was 25 when she made this sketch and it does indicate in the freshness and freedom of its paint treatment that Cassatt was already possessed of an independent mind as far as her painting was concerned.

PLATE 5
Mary Cassatt (far left), photographed in this modelling group at the Pennsylvania Academy of Fine Arts (1862)

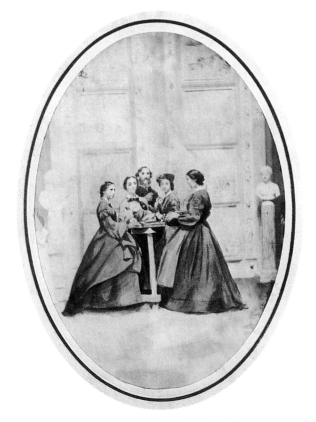

Mary left the Academy in 1865 and in the following year departed for Europe to make a study of the old masters at first hand. Although the United States has by now become the repository of many of the greatest works of all periods of art, either in private collections or public galleries, in the middle years of the 19th century such as were there were not available to any but the most privileged. A young girl of 16 would have seen them in engravings or even by that time in photographs but both these forms of reproduction could only serve to intrigue and partly inform, being a far cry from the originals. This is not always realized in these days when art of representative quality is widely held in many galleries.

When Cassatt arrived in Paris with her classmate and friend, Eliza Haldeman, what she encountered was a very different scene from the one she had left as a child 15 years earlier. Napoleon III was still in power; but only just. He had aggressive ambitions but from 1860 his control had become increasingly fumbling, he suffered from serious disease and was rapidly ageing. Since he came to power, however, he had achieved a transformation of the then still medieval city of Paris into a great modern city with the now well known wide and imposing boulevards and impressive classicist architecture. The transformation, inspired more by military considerations than town planning, was carried out by Baron Haussmann under Napoleon's direction. He had accomplished most of the

modernization of the services of the city by the time Cassatt arrived in 1866.

She immediately suffered a setback in that she was refused acceptance by the academic École des Beaux Arts. She was also dismayed by the conservative atmosphere she found in the art establishment and decided upon private study in the museums. In the Paris Exposition Universelle of 1867, she would have seen the work of Courbet and Manet, both of whom subsequently had an influence on her own work.

But dramatic changes were again on the horizon soon after she arrived. For several years from 1866, French feeling against Prussia had grown and Bismarck, the Prussian Chancellor, exploited this feeling to provoke the French into declaring war in July 1870, resulting in the so-called Franco-Prussian War. Rapid defeat followed and the French army capitulated in September 1870; a few days later a new republic was declared and the Empress hastened to England followed by Napoleon III himself. Sick and demoralized, he died there in 1873. Cassatt was obliged by the collapse of the whole social structure in Paris to return to Philadelphia and was not able to return there during the civil strife that later broke out in 1871 and 1872.

When she did return to Europe in 1872 it was to Italy where she pursued her studies of the old masters. In Parma, where she studied with the painter Carlo

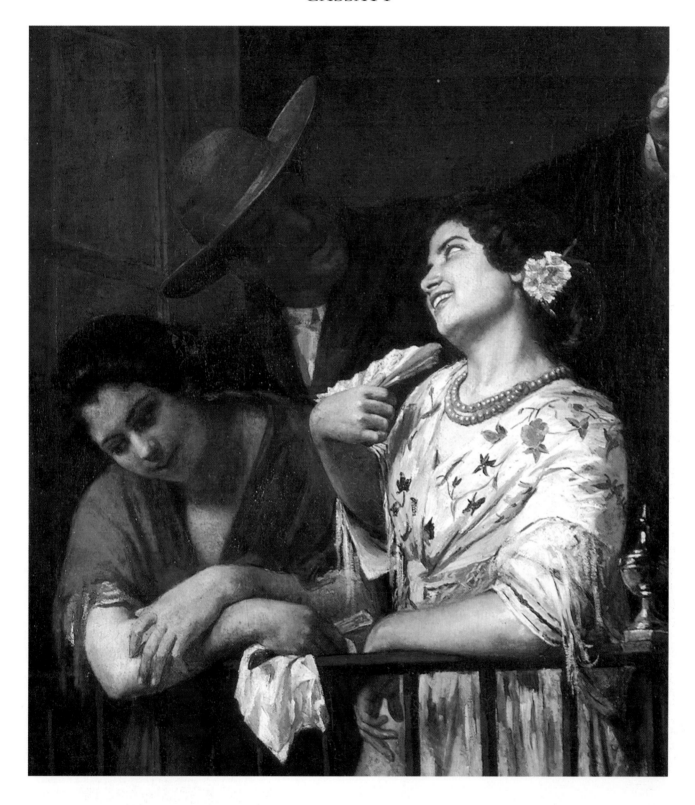

PLATE 6
On the Balcony, During the Carnival (1873)
Oil on canvas, 39³/₄ x 32¹/₂ inches (101 x 82.5cm)

Apart from the background of her traditional training in Philadelphia, the first real influence on Cassatt's work was that of the Spanish tradition of realism in genre scenes. Although her art departed from the traditional constructed compositions such as this she remained, like Degas, a determined realist in her intimate paintings which concentrated on the mother and child theme. The influence of Manet's painting, The Balcony, is evident here but the painting technique is still traditional and the influence of Murillo can be seen in the figure on the left.

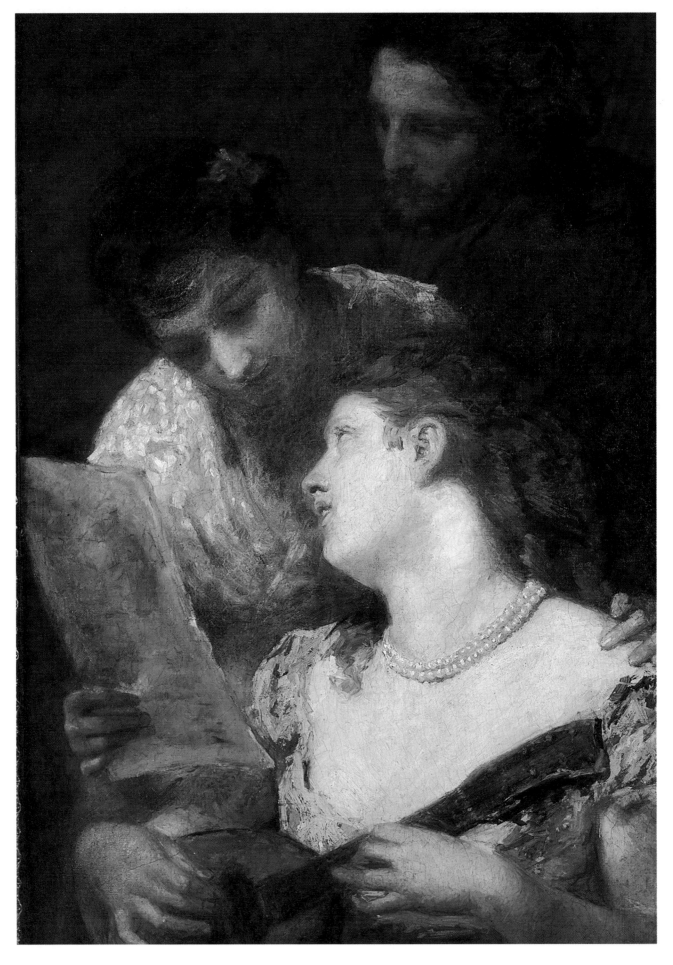

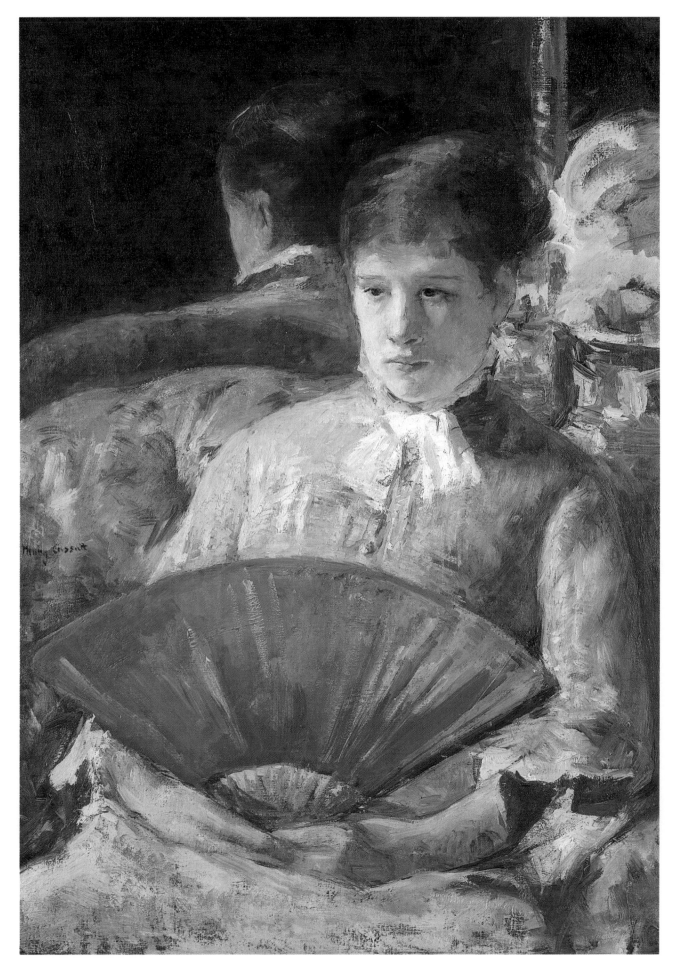

PLATE 7
A Musical Party (1874) page 18
Oil on canvas, 38 x 26 inches (96.5 x 66cm)

Cassatt was a cosmopolitan figure with a wide experience of European countries before she settled in Paris. During her travels she encountered a wide range of art styles and cultures and absorbed something from each, studying and painting in the cities she visited. This painting was made while she was in Rome and already exhibits an originality of composition which remains a feature of all her work. It is dominated by a sinuous S-curve rising from the fleshy chest through the turned backward tilted head, moving the viewer back into the picture, picked up by the turned shoulders of the second figure and completed by the dark head above. Additionally, there is a deliberate circular movement outlining the two lower figures.

PLATE 8
Mary Ellison (c. 1878) page 19
Oil on canvas, 33½ x 25¾ inches (85 x 65.4cm)

Mary Ellison was a friend of Cassatt's in the small American expatriate group in Paris in the period following the Franco-Prussian War and she is believed to be the subject of this theatrical painting inspired, as were a number of such works both by Cassatt and other painters, by Renoir's entrancing and elegant painting, La Loge. *Both Cassatt and Ellison were part of the theatre-going, gallery-visiting members of the privileged and monied circle in the city. This is a contemplative, introspective figure painted with the new free style that Cassatt was beginning to develop under the influence of Degas.*

Raimondi, she concentrated on the works of Correggio and Parmigianino, two of the greatest Mannerist painters of the early 16th century; from the former, she gained a knowledge of draughtsmanship and colour and from the latter compositional qualities. From Italy, Cassatt went to Spain where she visited the Prado in Madrid and studied the work of Velásquez, particularly the depiction of the royal children in his *Las Meninas*.

Cassatt returned to Paris in 1873 and began to submit to the official Paris Salon, an annual show; but in deference to her family's disapproval, she used the name Mary Stevenson for the first shows. Spanish art had influenced her considerably and the first works she painted in Paris were Spanish in subject (plates 2 and 6) and reveal one of the important influences on the earlier style of Cassatt's work, Édouard Manet.

The art world of Paris had changed dramatically since Cassatt had last been there only two years earlier and further developments were soon to change the situation further. Three years before her first departure in 1866, although she did not participate in them, events in the art world which were to change the last four decades of the century, and precipitated in 1863 by Manet, led inexorably to what has come to be known as the Impressionist revolution. By the time she returned in 1873 they were on the verge of public recognition.

Continued on page 28

PLATE 9
Self-Portrait (1878)
Gouache on paper, 23½ x 17½ inches (59.6 x 44.4cm)

The informal casual pose of this portrait reveals the influence of Degas and the brushwork is reminiscent of Manet. These two painters were the first influence in Cassatt's work after she settled in Paris. She had met Degas formally in the previous year and had become associated with the Impressionist group, first exhibiting with them in the group show of 1879. Her self-assurance and somewhat superior bearing are not evident in this painting, a study rather than a finished work since it is painted in gouache rather than oils.

There are few self-portraits by Cassatt (what there are are revealing) and portraiture was only undertaken for members of her family; there are no commissioned works. She regarded herself as a member of Parisian society with the added aura of being an American with fluent French. She was also conscious of her position as a professional woman painter who was financially independent. She was a successful manipulator of her social position who appears to have regarded even Degas and Manet as her social inferiors. Nevertheless, she was much influenced by Degas as this casual elegant pose indicates. Only the head is carefully delineated, the figure and particularly the hands being only simply sketched. As Degas might have done, she has enlivened the painting with sharp notes of colour in the hat.

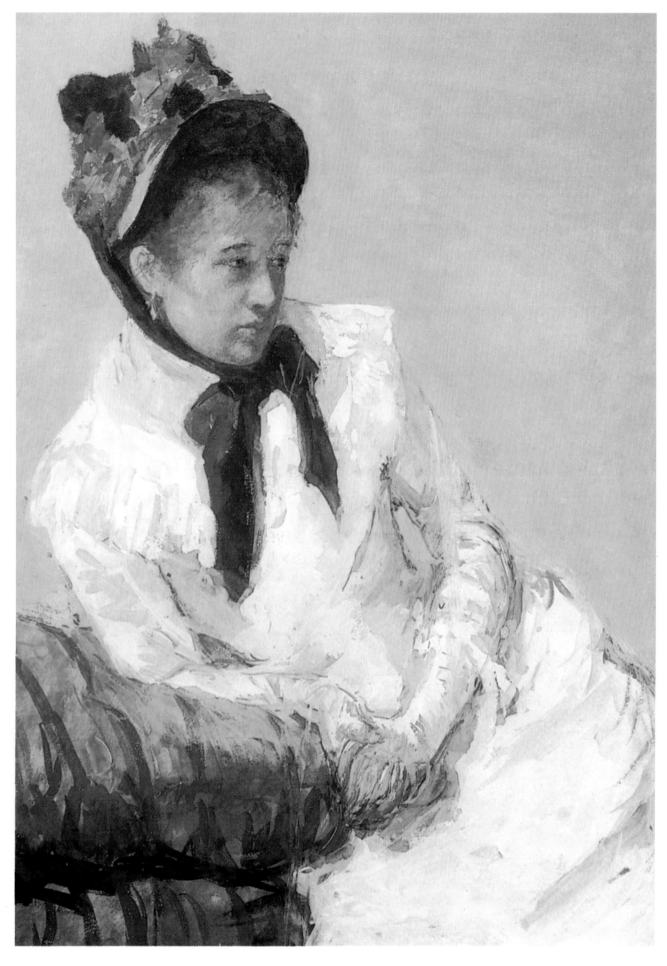

PLATE 10
Little Girl in a Blue Armchair (1878) detail
Oil on canvas, 35¼ x 51¼ inches (89.5 x 130cm)

Cassatt's opinionated point of view led to her abandoning the Salon route to success and the obligatory traditional methods when she became involved with the Impressionists and came under the influence of Degas, this painting being clear evidence of this in that its unconventional composition is indeed reminiscent of Degas. Indeed Cassatt claimed that he had himself painted part of the picture. If this is true it is surely an indication of a close relationship between the two painters.

The startling areas of blue, the unselfconscious languid pose of the child and the positioning of the elements makes this one of the painter's more original works from this period. The small Brussels griffon was Cassatt's and the sitter the child of a friend of Degas.

Little Girl in a Blue Armchair

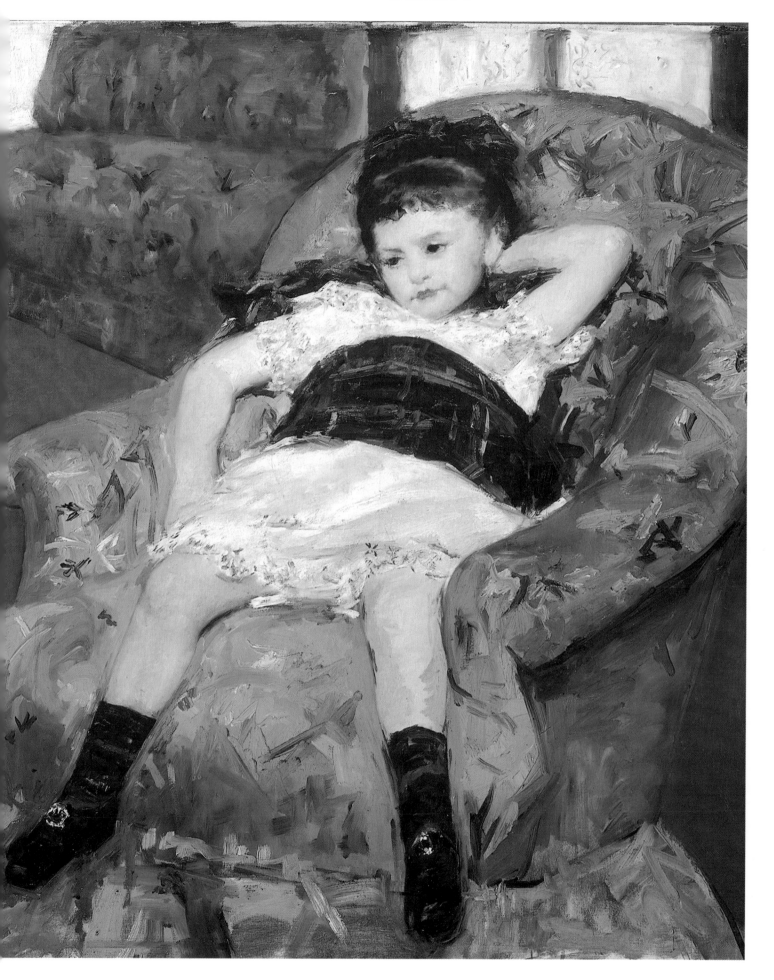

PLATE 11
Portrait of Moïse Dreyfus (1879)
Pastel on paper mounted on canvas, 31½ x 25 inches
(80 x 63.5cm)

An unusual example of an almost formal portrait of a male sitter

and outside Cassatt's usual subject treatment. The figure is observed without very evident sympathy in a traditional pose although Dreyfus was one of a number of collectors who were buying her work at this time.

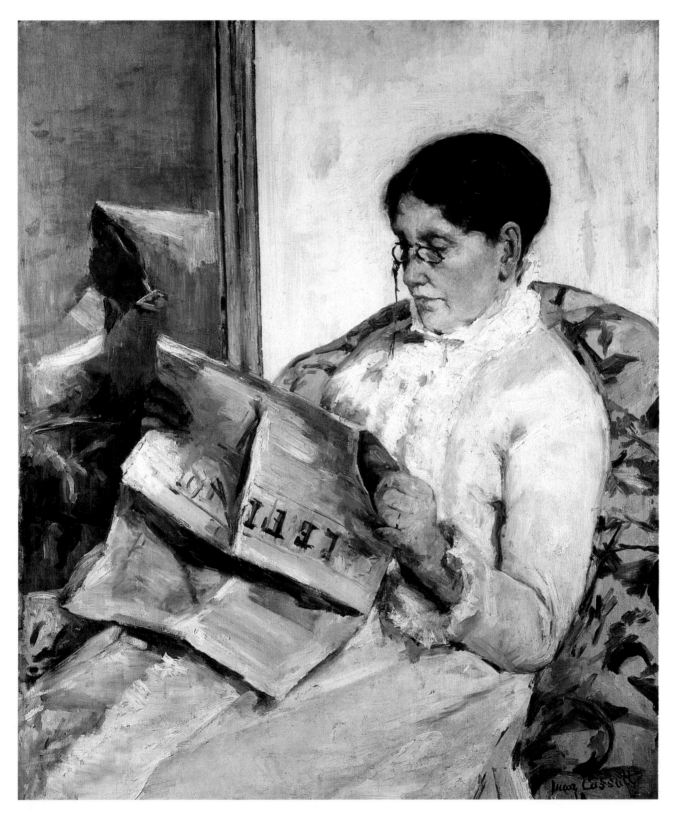

PLATE 12
Woman Reading *Le Figaro* (1878)
Oil on canvas, 39¹/₁₆ x 34¹/₂ inches (100 x 87.6cm)

Cassatt's carefully constructed painting in oils is of her mother, Mrs Robert Simpson Cassatt, engaged in an everyday activity, on this occasion reading a daily journal. By the time this painting was made, Cassatt was involved with the Impressionists and although there was no exhibition in this year she was already preparing to exhibit with them. The freedom of the new technique and method is already evident in this fine work.
(See also plate 33.)

PLATE 13
La Loge (1879)
Pastel and metallic paint on canvas, 26½ x 32 inches
(67 x 81.2cm)

*This was an acceptable social activity and the elegant painting of
the box at the theatre painted by Renoir and exhibited in the first
Impressionist exhibition in 1874 was already known to Cassatt.
She used this situation a number of times and this is an example
of her Degasesque treatment of the subject. Pastel was a method
of which Degas made the most original use, and to great effect,
and Cassatt followed his lead. The careful texture of the partly
hidden face in smoothed pastel is contrasted with the coarse bold
treatment of the fan which in turn is contrasted with the smooth
flow of the clothed arm. The arm and hand holding the fan is
treated in yet another way in across-the-form strokes of pastel.
Altogether, this is a lively, appealing image.*

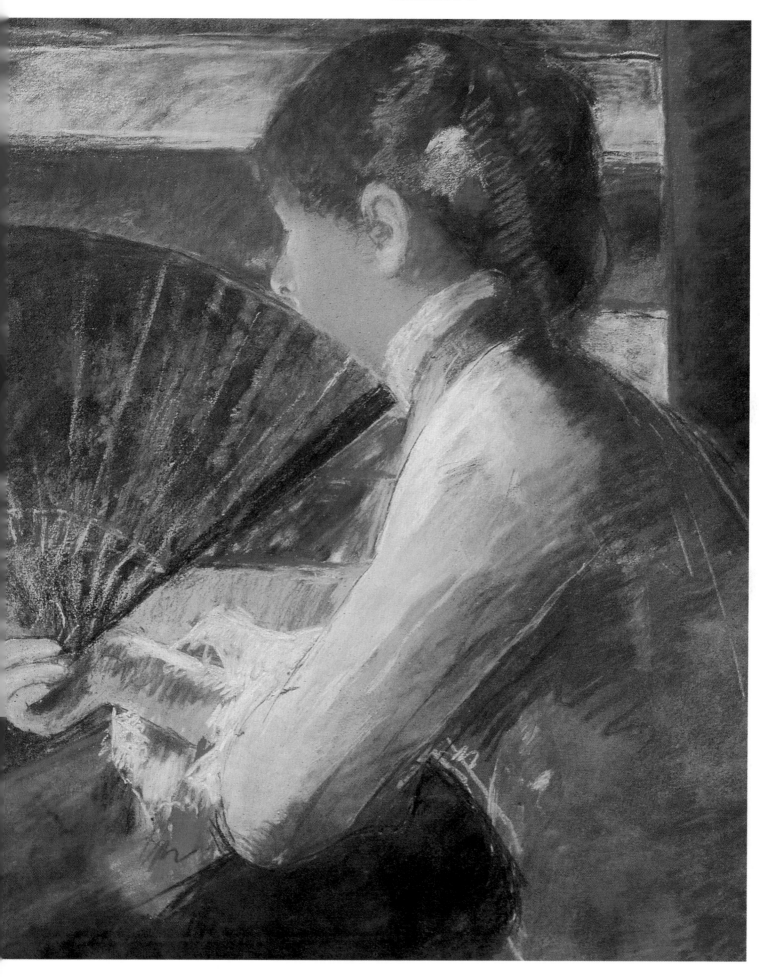

PLATE 14
Self-portrait (c. 1880) below
Watercolour on paper, 13 x 9⅝ inches (33 x 24cm)

Of the few self-portraits that Cassatt produced, this watercolour is the most immediate and direct, unflattering and spontaneous but with a calculated self-awareness which reveals far more than a studied oil, such as plate 7, may do. One senses that it might have been the result of a hiatus, such as waiting for a model, that prompted the work; but the fact that it is signed with her initials suggests that she attached some importance to it. At all events, it suggests a no-nonsense forcefulness of character and a keenly quizzical eye which was the view many have put forward of her.

PLATE 15
Portrait of a Young Woman in Black (1883)
detail opposite
Oil on canvas, 31½ x 25¼ inches (80 x 64cm)

This dramatic portrait of an unidentified sitter is an example of Cassatt's independent confidence in her use of oil paint. The pale cream arm of the chair, with its strong pattern, forms a lively opposition to the simplified black figure and the carefully observed face behind its veil.

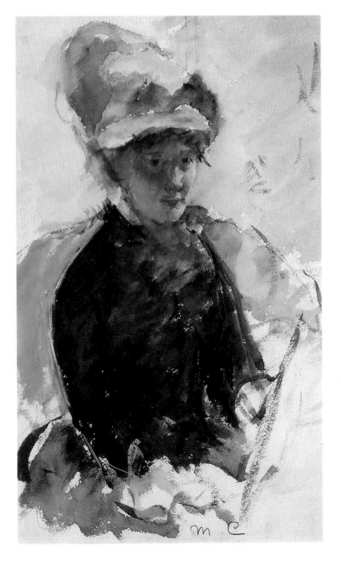

Continued from page 20

THE BACKGROUND TO IMPRESSIONISM

A number of influential mentors stand between the Impressionists and what was then their only acceptable outlet – the academic exhibitions. The most significant event of the artistic year in France was the annual Salon, held in the Grand Salon of the Louvre Palace in Paris. Exhibitions of fine art had been held periodically, interrupted by war, changes of dynasty and disagreements at different locations in Paris since 1673: but since the Revolution they had been suspended until 1833 when an annual exhibition was decreed in the Grand Salon with a liberally-minded selection committee composed of a wide range of interests, from professional to amateur. Louis Philippe soon changed this, giving control of admission and responsibility for distributing prizes to the conservative Académie des Beaux Arts, thus ensuring that no unorthodox artistic work would be admitted. This restrictive, conservative and exclusive régime continued through the middle years of the century and, as it tightened its grip, caused resentment among artists, especially those from outside the establishment and which, of course, particularly affected the young and unrecognized. By the 1850s, these very people formed a part of café society, gathering together to discuss possible changes to the status quo.

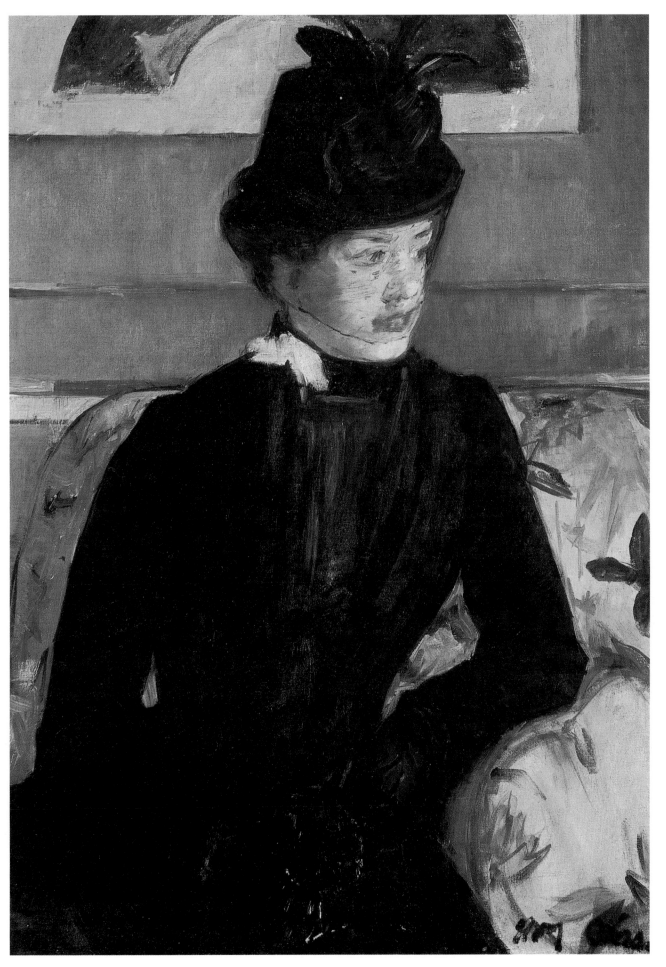

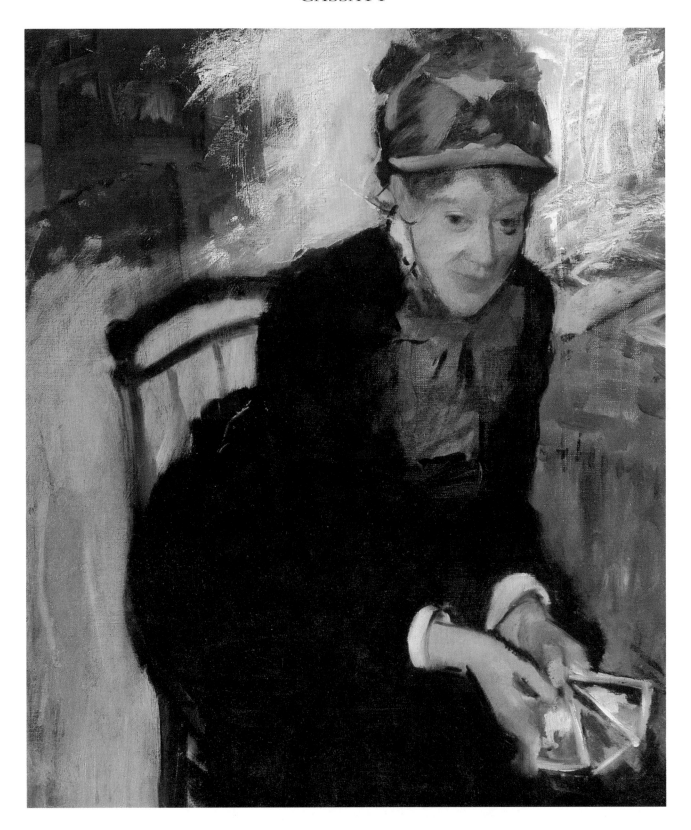

PLATE 16
Edgar Degas' Portrait of Mary Cassatt
(c.1880)
Oil on canvas, 28$^1/_8$ x 23$^1/_8$ inches (71.4 x 58.7cm)

Cassatt herself never liked this informal portrait by her friend and mentor. She is represented more as a paid model in working clothes than the elegant society lady that Cassatt conceived herself to be and this probably accounts for the dislike. It is nevertheless a sharply observed and brilliantly drawn sketch which contrasts with the quieter statements of Cassatt. She seems to be holding photographs or, as has been suggested, tarot cards, either of which she would not have approved of in a portrait of herself.

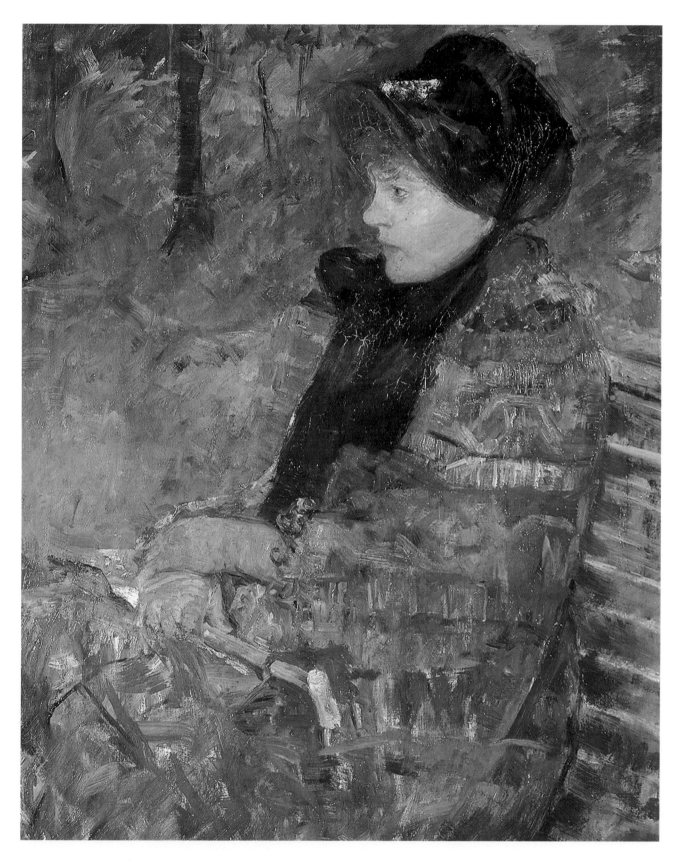

PLATE 17
Portrait of Lydia Cassatt (1880)
Oil on canvas, 36½ x 25½ inches (92.7 x 64.5cm)

The free brushwork in the background of this painting and the

delicate draughtsmanship of the head show the increasing confidence of Cassatt's work. The sitter is her sister with whom she was very close and who appears with her in Degas' gallery painting and etching. The brightness of the colour is balanced by the black of hat and scarf.

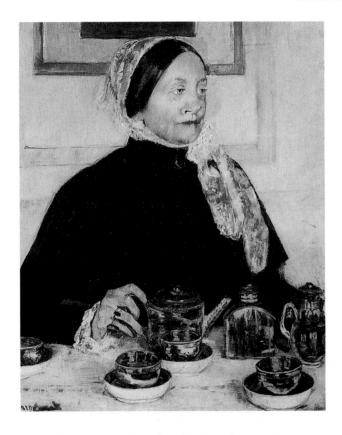

PLATE 18
Lady at the Tea Table (1885)
Oil on canvas, 29 x 24 inches (73.6 x 61cm)

The sitter is Mrs Mary Dickinson Riddle, a first cousin of Cassatt's mother and the painting was paid for with the elegant Japanese teaset depicted and which was presented by the sitter's daughter, Annie Riddle Scott. Of course it was designated a gift, avoiding any suggestion of a commercial deal, and Cassatt is perhaps emphasizing this point by naming the picture thus. However, it remains essentially a portrait.

A favourite meeting place for the painters who were to become the Impressionists was the Café Guerbois in what is now the avenue de Clichy, in Montmartre. From 1866, regularly on a Friday, Manet, the somewhat reluctant leader of the group, met with writers, art critics and painters, among them Zola, Duranty, Duret, Degas, Bazille, Monet, Renoir, Pissarro, Sisley, as well as the sculptor Astrac, the engraver Bracquemond, the photographer Nadar and two painters outside the Impressionist circle, Constantin Guys and Alfred Stevens. The new realism was discussed, as well as the means of publicizing it and resulted (before the Franco-Prussian War broke up the meetings) in the polemicist writings of Zola, then a close friend of Cézanne who also made spasmodic visits to the Café Guerbois while remaining sceptical and not necessarily concurring with the ideas on offer. The meetings resumed after the war, with Manet maintaining his central role. It was here that Monet met the great French intellectual and politician, Georges Clemenceau, who became his great friend and a primary influence on Monet's career.

The first organized attempt at circumventing the academic restrictions was made by a number of artists, founders of the Association des Artistes, which quickly grew to 3,000 members, among them Eugène Delacroix, Honoré Daumier, Théodore Rousseau and Jules Dupré, all of whom are still remembered as are few of the

academicians. They planned an independent Salon but it was never to materialize as a free Salon was opened in the Louvre after the creation of the Second Republic in 1848. Increasing conservatism in politics had its parallel in the academic art scene which virtually controlled patronage and the director-general of national museums, the sculptor Alfred-Émile O'Hara, Count Nieuwerkerke, so dominated the French art scene that the élitist exclusivity of the Salon caused real anger and resulted, in 1863, in the establishment of the Salon des Refusés by order of Napoleon III in which works were shown which had been rejected by the Académie des Beaux Arts. The intention was thus to demonstrate the superiority of academic art.

The Salon des Refusés indirectly initiated a programme that led, a decade later, to the first exhibition by the Impressionists. The major importance of the exhibition was that it created a scandal of such proportions that a number of academics and intellectuals felt themselves obliged to confront the problem of academic conservatism and its effect on artistic creativity.

The cause of the scandal was the seminal and now famous confrontation of popular prejudice and artistic practice. Among the exhibits in the Salon des Refusés was Édouard Manet's painting, *Le déjeuner sur l'herbe*, which he intended as a modern interpretation of an academic subject. The composition was inspired, it seems, by an engraving by Marcantonio Raimondi after a painting by

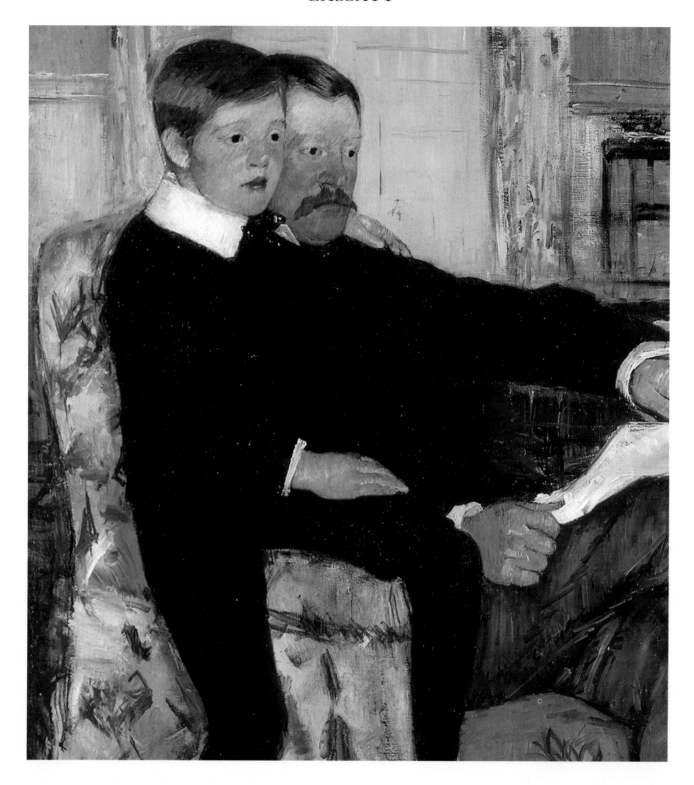

PLATE 19
Alexander Cassatt and His Son Robert
(1885) detail
Oil on canvas, 39½ x 32 inches (100.3 x 81.2cm)

As already noted, Cassatt painted few male portraits – almost none that were not members of her family and her elder brother and his son are the sitters for this unusual composition. The posing of the figures so that their eyes, concentrated on the same object, form a single close-linked line is so clearly a contrived effect that the physical closeness of the bodies is only given credence by the unified black of their clothes. This black shape which spreads over the centre of the canvas is surrounded by the pinks, reds and creams of the furniture and repeated in the faces. It can only be intended to indicate the closeness of the relationship between father and son. Alexander was a successful executive of the Pennsylvania railroad and his relaxed self-confidence is evident.

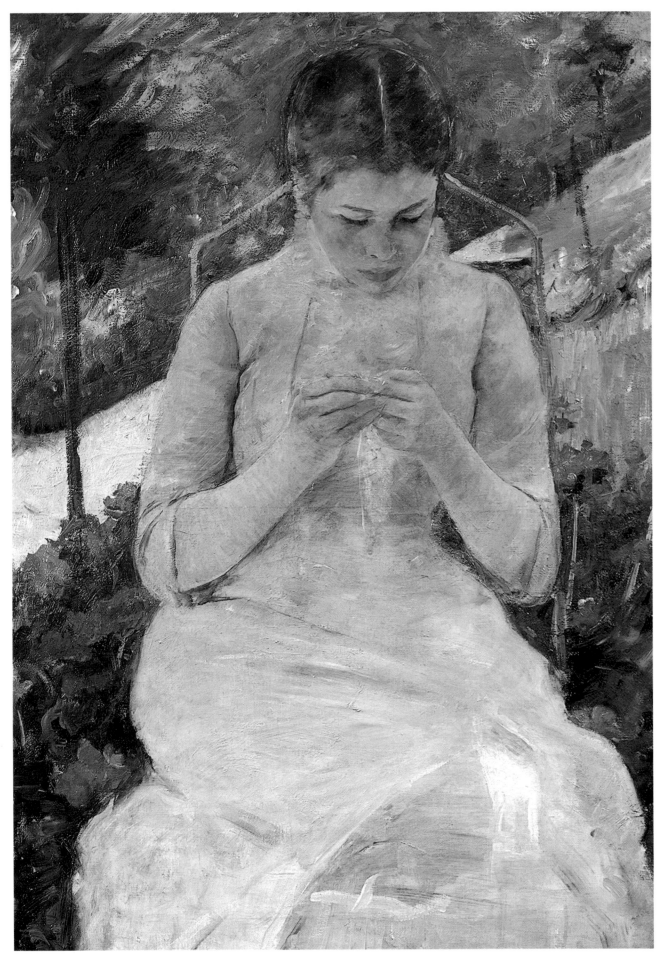

PLATE 20
Young Woman Sewing (1883–86) opposite
Oil on canvas, 36 x 25½ inches (91.4 x 64.5cm)

*The sitter is presented in steep perspective, suggesting that the
artist is standing close to her, producing a feeling of intimacy and
collaboration. Although the young woman is presented engaged in
an activity acceptable in the social milieu in which Cassatt
revolved, it usually means that when the sitter is not clearly
identified by name that she used a paid model and it seems
apparent in this case, there being a certain awkwardness and
gaucherie in the figure.*

PLATE 21
Girl Arranging Her Hair (1886)
Oil on canvas, 29½ x 24½ inches (74.9 x 62.2cm)

*This painting was exhibited at the last Impressionist show where
it was admired by Degas who exclaimed, 'What drawing, what
style!'. He later exchanged it for one of his pastels and kept the
painting until he died.*

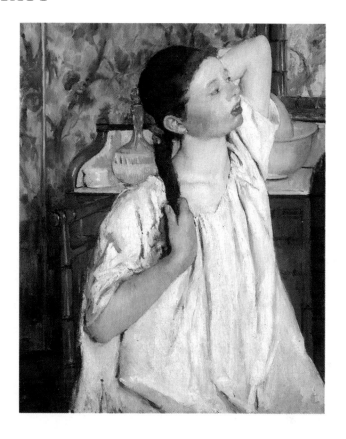

Raphael. Although originally somewhat obscurely entitled
The Bath, it depicts what can be best described as a
harmless picnic in a park. Two elegantly dressed men-
about-town are seated on the grass in a sylvan setting,
accompanied by a naked woman who gazes boldly and
unashamedly towards the viewer. A fourth figure, of a
female either dressing or undressing in an undefined area
of water, is seen in the background. The painting
scandalized all who saw it and it is reported the Napoleon
III ordered his wife to avert her eyes. It ensured that the
experimental exhibition was not repeated.

It is important to realize why the painting so
scandalized the public. Certainly, it was not because the
female figure was nude. The nude had long been a subject
of academic painting, often in deliberately exaggerated
poses of intentional eroticism. The cause of disapproval lies
in the title: the academic would have entitled the same
subject 'Venus in the Garden of Eden' or some such
nonsense set in the remote past. Such a title would have
had the effect of distancing the subject from an actual
event, placing it firmly in the realms of history, mythology
or religion – Rembrandt's *Susannah and the Elders*
(*Susannah Bathing*) comes to mind.

Subject-matter in French academic painting was
therefore important and taken almost exclusively from the
three sources of mythology, history and religion.
Technique was also important and development was by

that time very much affected by the French Revolution. It
was obviously not now appropriate to continue the
elaborate exoticisms of the court art of the late 18th
century, as seen in the work of Boucher and Fragonard,
and a sterner, more propagandist method was demanded. It
was provided by Jacques-Louis David, foremost among the
proponents of Neo-Classicism which, as the name
suggests, was a new classicism inspired by the Roman
Republic rather than by Greece, his subjects often being
recreations of the history or mythology of Rome. His
painting, *Brutus Receiving the Bodies of His Dead Sons Whom
He Had Executed for Treason to the State*, was exhibited in
the Salon of 1789, at the time of the fall of the Bastille,
and is taken to indicate the superiority of patriotism over
familial duty. David was a survivor, becoming the painter
to the Revolution and a friend of Robespierre. He escaped
the guillotine and was subsequently official painter to
Napoleon. He died in 1825 and his pupil and follower,
Jean-Auguste-Dominque Ingres (1790–1867), became the
leading classicist.

By reputation a greater painter than David, Ingres
inspired the admiration, not only of academics but also of
the young independents or realists, as they liked to be
called, who had gathered around the hero of the Salon des
Refusés, Manet. Apart from Manet, they had other
painters of an older generation to admire, especially
Gustave Courbet and the Barbizon painters of the Forest

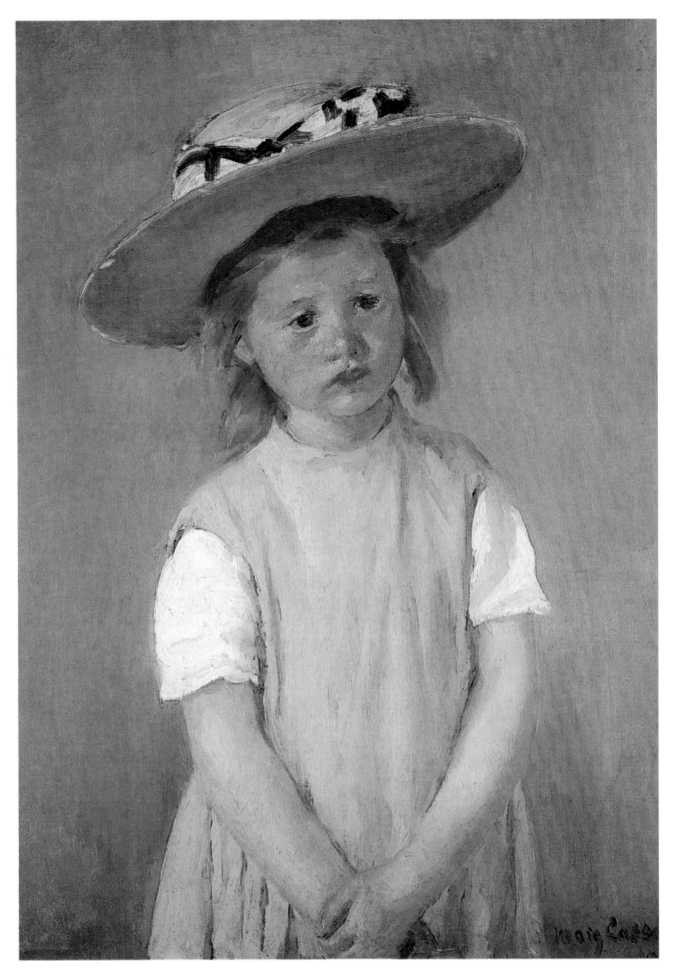

PLATE 22
Child in a Straw Hat (c.1886)
Oil on canvas, 25³/₄ x 19¹/₂ inches (65.4 x 49.5cm)

The melancholic insecurity in this young girl's expression is emphasized by the simple flat background and plain costume in cool colours which she is wearing. The Impressionist character of Cassatt's work is beginning to be replaced by a more refined and careful technique in this and later work.

of Fontainebleau – Corot, Rousseau and Diaz de la Peña. These painters were also outside the academic mould, being rather more interested in *genre* and landscape painting than historicist or religious subject-matter. Their methods of painting were basically academic, although more freely executed and, most significantly, painted out-of-doors, *en plein-air*, with their subjects in front of them.

Gustave Courbet (1819–1877) was a man of great independence of spirit, with a fierce loyalty to the rural way of life of his village and its environs which he translated into paintings of great sympathy and an awareness of the harsh realities of peasant existence. For the young painters, his character and the individuality of his art, very different from academic treatment in its rough paint surfaces, was a considerable inspiration in their search for a more appropriate 'painterly' treatment, rather than the traditional smooth tonal paint surfaces and precisely constructed forms.

Another artist of significant influence was Eugène Delacroix who was born in 1798 and died in the year of the Salon des Refusés, 1863. Delacroix was the greatest of the French Romantic painters and a parallel and opposing influence to the classicism of Ingres with whom he was almost an exact contemporary. His work was of particular interest to the young realists/independents in that it had a free and expressive technique which, although essentially tonal like the classicists, was executed with strong brushstrokes and brilliant colour, giving his work a force

and a passionate and immediate sense of actuality.

This was the background into which the art of Impressionism developed and from these many influences it is not difficult to imagine the direction in which its exponents sought to proceed. They were, of course, not interested in constructing either large historicist 'masterpieces' such as those produced by academics, nor of maintaining the conventional technique of constructed form and tonal composition. They were repulsed by the endless repetitiveness of the Beaux Arts subjects and sought to introduce a freshness and immediacy of approach to their subjects. They were little concerned with the presentation of illusionist spatial recession which seemed to them to remove all vitality and spontaneity which they considered to be above all necessary. Impressionist paintings look first and foremost like paintings. The Impressionists recognized a limitation and separateness from nature in the constructed academic images of solid, dense form and felt that light was the important element that was missing. They explored the effect of light and made discoveries which transformed their paintings. To the public that first saw them, they seemed unfinished and indistinct; they used bright colour and edges were undefined, painted in small dabs, each visible and not as smoothly applied as in an academic work in which the brushstrokes could not be seen – only form, tone and a little local colour.

In the decade following the Salon des Refusés, these

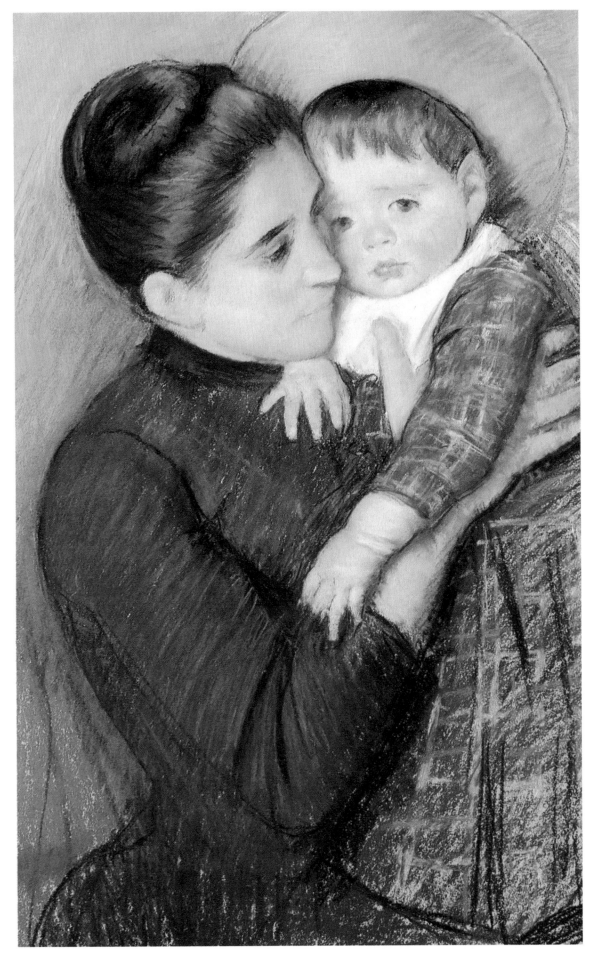

PLATE 23
Hélène de Septeuil (1889–90) opposite
Pastel on paper, 25⁷/₈ x 16¹/₂ inches (65.7 x 42cm)

*It is not surprising that Cassatt became an accomplished pastellist
under the influence of Degas, one of the greatest of all
practitioners of the method. This pastel is of Hélène, a young
citizen of Septeuil, a town about 18¹/₂ miles (30 km) west of
Paris near Mantes, where the Cassatt family spent the summer of
1889. It should be remembered that Cassatt used models for
most of the mother and child paintings she made, choosing them
for the effect they produced rather than any other consideration.
The quality of the drawing and the sense of empathy that Cassatt
manages to express in the figures seems to belie the fact that they
were not related.*

PLATE 24
Young Woman at the Window (c. 1890)
Pastel and charcoal, 29¹/₃ x 24²/₃in (74.4 x 62.4cm)

*A characteristic example of an image constructed using models for
mother and child.*

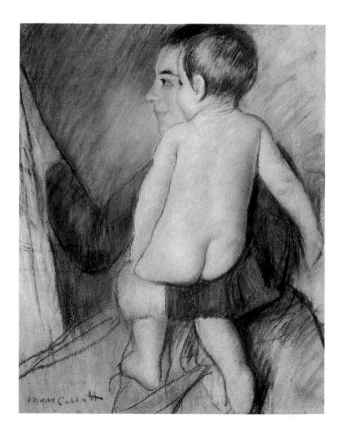

notions were slowly identified and, after the separation
caused by the war of 1870, planned and made apparent
until, in 1874, they exhibited together as a group for the
first time. And this is where all the problems of
identification begin.

The exhibition was held in the former studio of the
great early photographer Nadar, a friend of the group in
the days of the Café Guerbois, and was called the
'Première Exposition de la Société Anonyme des Artistes,
Peintres, Sculpteurs, Graveurs'. The principal organizers
were Edgar Degas and Claude Monet, while other artists
included Pissarro, Sisley, Cézanne, Berthe Morisot and
Renoir, all of whom would now be included in any study
of Impressionism. Not included was Manet, who never
exhibited with the Impressionists (but on this occasion
refused because he objected to the inclusion of Cézanne),
Mary Cassatt (who did not exhibit until 1879), Caillebotte,
an amateur painter and Impressionist collector, and Bazille
who, although an original and important member of the
group, had been killed in the Franco–Prussian War. Other
well known artists who were not then or later to be
classed as Impressionists were among the exhibitors,
including Boudin, Bracquemond and Astrac.

At this time, the exhibitors did not describe
themselves as Impressionists and did not think of
themselves as such. Indeed the term was not in general use
in art criticism although it had been used to describe

specific paintings. The two terms that they would
generally have accepted were, as we have noted,
'independent' and 'realist'. Furthermore, a number of the
exhibitors were not then nor have been subsequently
associated with Impressionism. Degas himself, often seen
as a figure central to Impressionism, always rejected the
term and preferred to be called an independent, or
preferably realist, and Degas, in any case, does not easily fit
into the category.

One encyclopedia suggests the term can be used to
describe most of the painters of the latter half of the 19th
century who were opposed to the academic tradition and
led art back to perceiving objects as they really were and
rendering them in a sensory, visual way through the use of
colour. One writer, Duret, wrote the first pamphlet about
the Impressionist painters in 1878, implying that a direct
communication with nature, *en plein-air*, is necessary. He
remarks: '...the Impressionist sits on the bank of a river;
according to the sky, his angle of vision, the time of day,
and the calm or agitation of the atmosphere, the water
assumes various tones, and the painter paints, without
hesitation, the water with all its tones.' It is perhaps this
immediacy and contact with his subject that identifies the
Impressionist. It seems, too, that by the year 1874 (by
which time all the painters were mature and in control of
their art), the significant features of Impressionism were
now in existence.

PLATE 25
Mother Combing Her Child's Hair (c.1901)
Pastel and gouache on tan paper, 25¼ x 30⅗ inches
(64 x 77cm)

The use of a mirror to enlarge both the spatial content of the painting and the information regarding the subject is a feature found in many historical examples and Cassatt also uses the device on occasions as here. The colour key to the pastel is the basic tan paper. It is a common practice to use coloured grounds to effect unity and the cool quality of this work is achieved by this means on which the yellow/green/orange scheme is effectively constructed. It will also be noted that the drawing is more controlled and finished than in much of Cassatt's earlier work, the result of her reawakened interest in the old masters in her later years.

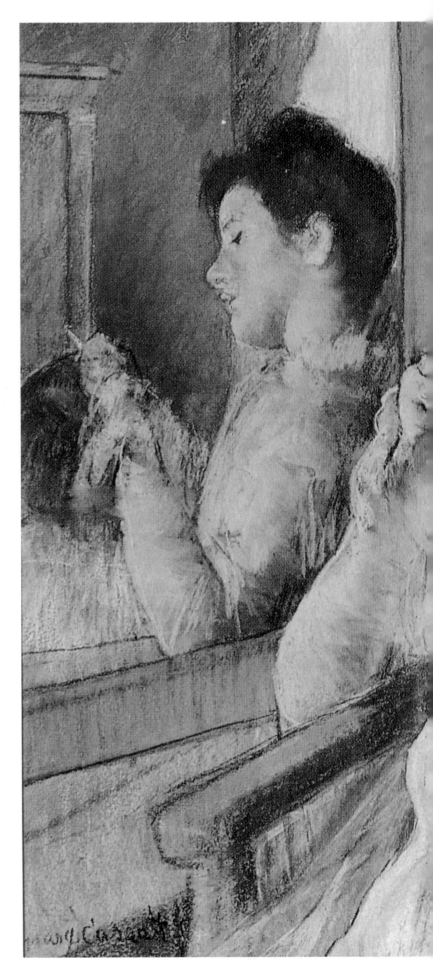

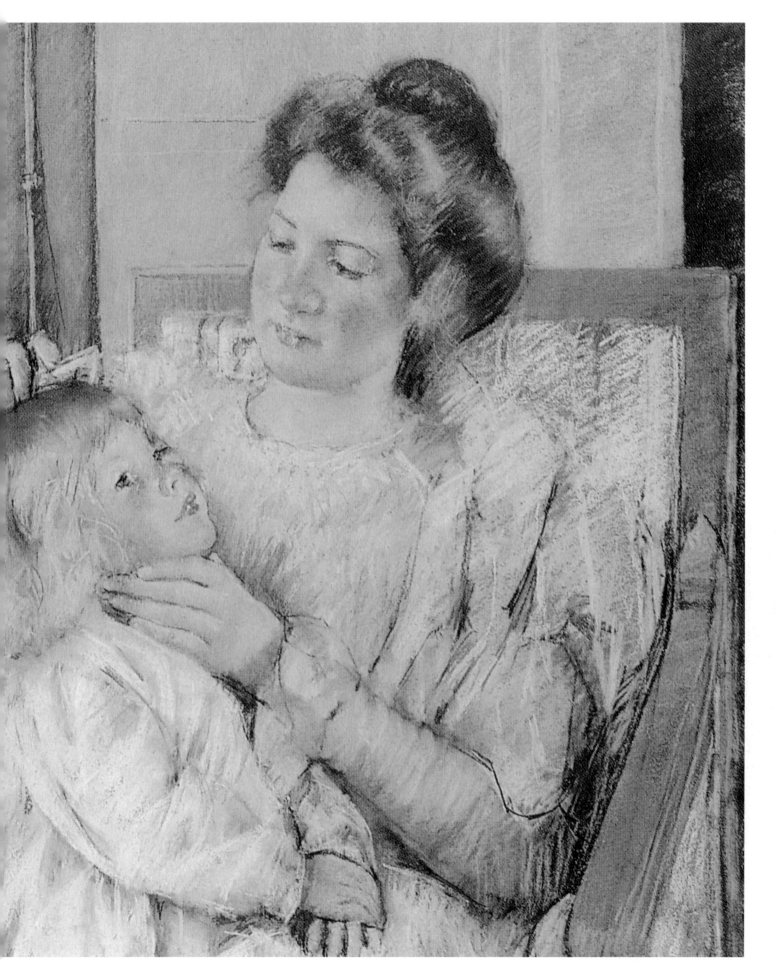

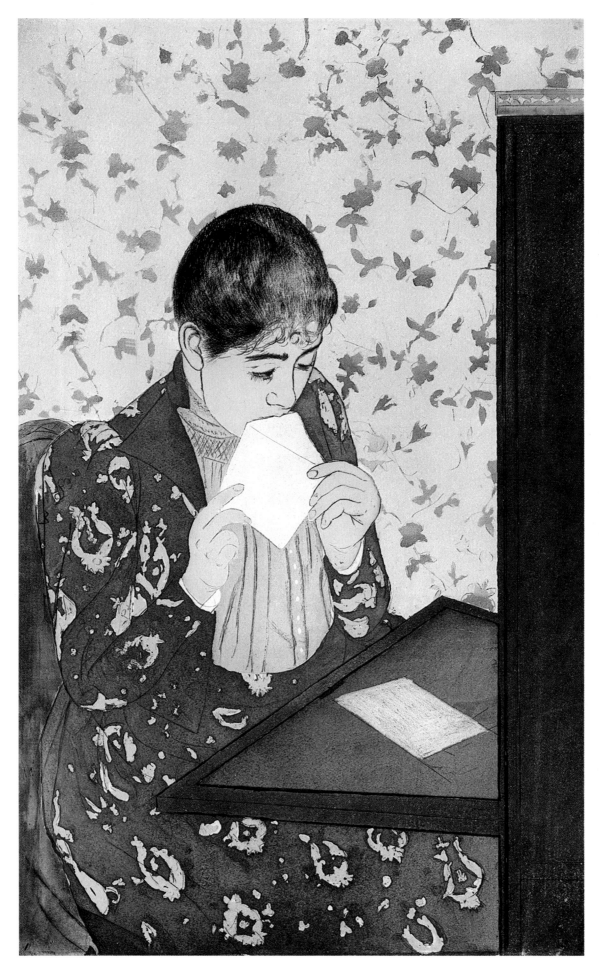

PLATE 26
The Letter (1890–91) opposite
Drypoint and colour aquatint on laid paper,
13⅝ x 8¼ inches (34.5 x 21cm)

*Only four states of this print are known but it is one of a series
that Cassatt had worked on for most of 1890. The mixture of
patterns flatly treated are reminiscent of Vuillard's paintings of
similar indoor domestic subjects.*

*Cassatt made a set of ten prints for the project which she had
intended to show at a printmaker's exhibition in 1891 but was
excluded from the exhibition because she was a foreigner.
However, Durand-Ruel, at whose gallery the show was mounted,
allowed her a room of her own in which to show her work. This
is probably the last in the series.*

PLATE 27
The Bath (c. 1891) below
Drypoint and soft-ground etching and aquatint,
14¾ x 10½ inches (37.5 x 26.7cm)

*Cassatt's well known attraction to various methods of
printmaking, inspired in the first instance by Degas, resulted in a
number of highly individual images in a variety of printmaking
techniques, often the result of personal experiment. Not
surprisingly, some of her works in this medium are highly
effective. The forceful simplicity and careful balance of this design
makes it one of her most clearly stated examples. Its linear
definition is finely related to its delicate colour.*

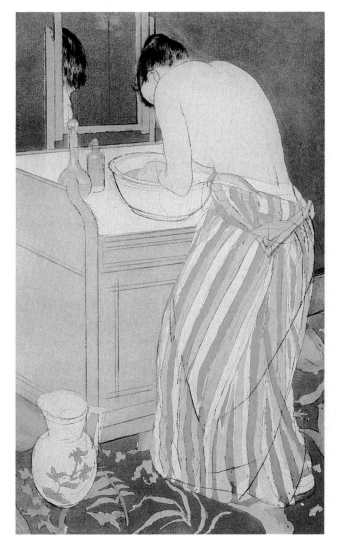

By the end of the decade, and around 1880, the
Impressionists had accomplished their revolution and were
becoming increasingly recognized and successful. But
Degas, as already noted, not only never painted *en plein-
air*, but actually deplored such an activity, going as far as to
suggest that any one who practised it should be followed
by gendarmes and discouraged with bird-shot. In which
case, if open-air painting is a criterion, Degas was not an
Impressionist. Such qualifications of different kinds may be
applied to others of the group.

Manet had painted a number of Spanish subjects in
the 1860s and Cassatt, as noted above, saw his show in the
Exposition Universelle of 1867. Her main activity
immediately on her return to Paris was to concentrate on
single figures, a number of which portray women playing
musical instruments, such as *A Musical Party* (plate 7).
Some of these and her portraits were submitted to the
Salon and accepted from 1872 onwards. In 1874 she
studied in Paris with a popular and fashionable French
painter with the now familiar name of Charles Chaplin. In
the same year she exhibited a painting of Mme. Cartier at
the Salon. This is the first painting of hers that Degas
commented upon: 'This is real. This is someone who feels
as I do.' Degas became a close friend of Cassatt's when
introduced some three years later to her by a mutual
friend, Joseph Tourney – at least as close a friend as an
irascible, witty and sharp-tongued misogynist can be. In

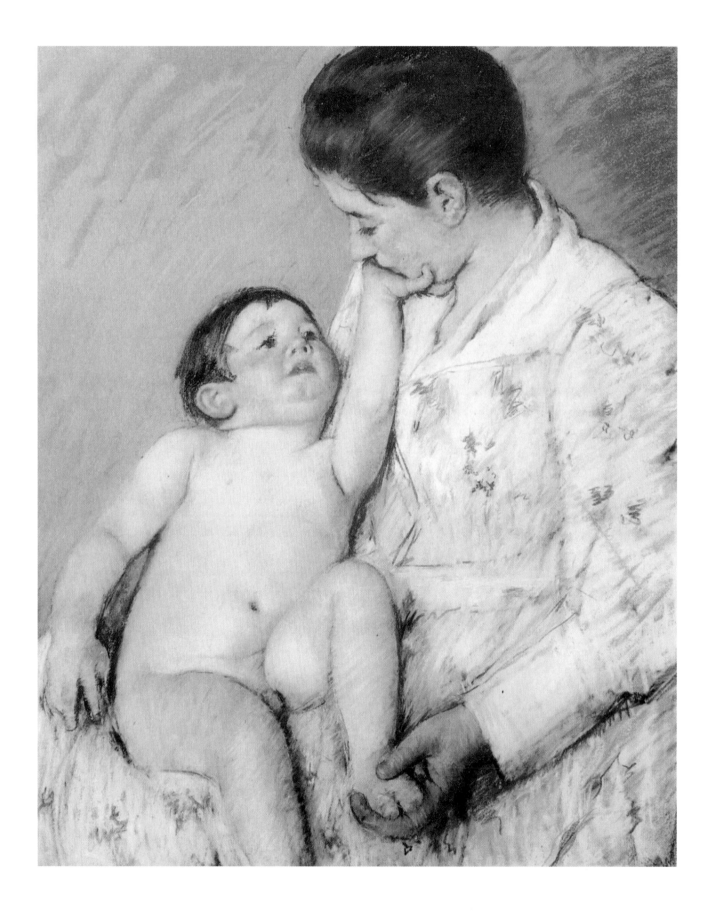

PLATE 28

Baby's First Caress (c. 1890) opposite

Pastel on paper, 30 x 24 inches (76.2 x 61cm)

The tenderness of maternity and the total confidence of childhood are beautifully expressed in this carefully designed pastel. The contra-movement of hands, the way the mother supports the child's foot, his concentration on examining by touch the face of his mother, all create a unity of sympathy. The colour is clean and warm, the whole effect admirably convincing. The sitters were almost certainly models and a naked boy is unusually represented rather than the usual female child.

PLATE 29

The Fitting (1890–91) right

Drypoint, soft-ground etching and aquatint,
14³/₄ x 10 inches (37.5 x 25.4)

Another stage in the series of prints on the toilette. (See plate 27.)

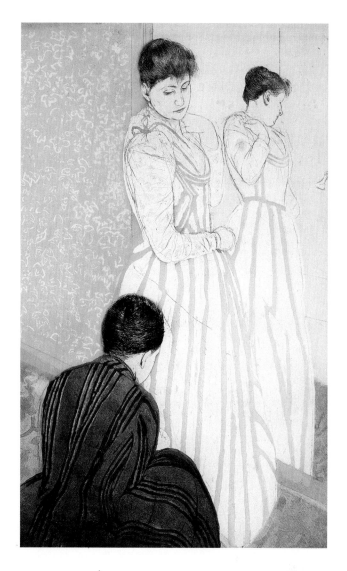

1877 he asked her to join the Impressionists and she began to exhibit with them two years later in 1879 and afterwards in the shows of 1880, 1881 and 1886 (the last held by the group). Her association with Degas and the Impressionists will be considered later.

By 1877, the Cassatt family had joined Mary in Paris and became the subjects of a number of her paintings, especially her sister Lydia, who is probably the figure in plate 13. The painting recalls a subject used by other Impressionists, the most notable being Renoir's *La Loge* (1874). Subsequently, Cassatt used the same theme in a number of pastels and etchings as well as in oils with Lydia as model. Another member of the family, Alexander, her brother with whom she was very close, came to Paris in 1880 with his family which inspired Cassatt to explore a subject of which she never tired – young children, either individually or with an adult, frequently their mother. It is perhaps a little surprising that this subject interested her. She appears to have been a warm-hearted though sharp and authoritarian woman with a deep attachment to family values, unmarried and ambivalent towards men, perhaps a little afraid and repelled by them – an almost classic example of projection and perhaps of sublimation of her own maternal instincts. Moreover, the warmth and sympathy that emanates from these works is so strong as to almost invalidate her Impressionist credentials. It is important in this context to recall that her studies in Italy were importantly focused on Correggio and Parmigianino, both renowned for their Madonna and Child paintings.

After their first meeting, Degas had gradually become a close friend and supporter of Cassatt and their relationship was of considerable interest and importance to both. Degas gave her encouragement and thought highly of her work. He also invited her in 1880 to participate in the foundation of the journal he planned, *Le Jour et La Nuit*, which in the event never got off the ground, but which directed her interest towards the reproduction techniques of printmaking, particularly etching, in which she had been given basic instruction by Raimondi during her stay in Parma. Cassatt's mother attributed the failure of the magazine to her belief that 'Degas is never ready for anything'. It was at this time, however, that Degas produced the series of etchings of Cassatt and her sister Lydia in the Louvre.

Cassatt's friendship with Degas is interesting in itself and has occasioned much speculation. It would have been usual and taken for granted in the art world of Paris in the

PLATE 30

Mother's Kiss (c. 1891) below

Drypoint and soft-ground etching in colour,

14¹/₂ x 10³/₄ inches (36.8 x 27.3)

PLATE 31

The Bath (The Child's Bath) 1890–91 right

Drypoint, soft-ground etching and aquatint,

12⁵/₈ x 9³/₄ inches (32 x 24.7cm)

Cassatt was more adventurous in her prints than in her paintings which she only began after a visit to an exhibition of Japanese prints with Degas (see page 49). She had already established her painting methods which only changed later in life, but with this new technique, and helped by Degas, she explored a more firmly patterned style and an almost oriental draughtsmanship of which these prints are a good example. Each plate is coloured by hand and there are at least 17 different states of plate 31.

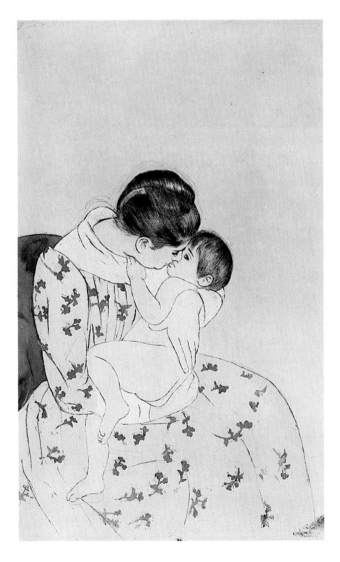

later 19th century that they would have become lovers had Cassatt been a married woman. But as a single woman living with her mother she would, in the same circumstance, have been publicly compromised and probably socially ostracized. In Degas, however, we have not only something of a misogynist with a biting tongue but also a social snob. Of the same 'class' as Cassatt and with American connections (his mother was a Creole from New Orleans) she would have provided the only socially acceptable partner from the Impressionist circle and being well educated, with the same interest in European art and financially secure, there existed for Degas a possible affinity. (They had both visited the same countries to study though Degas had by this time lost his money in the failure of the family bank.) On the other hand he had a number of women friends, some of them well known painters, and was something of a divided personality who could at times be the intellectual life and soul of the dinner party and at others bitingly rude to all and rejecting any association with them. For Cassatt, inexperienced in relationships with men, and from the evidence of her work, uncomfortable with them, the intellectual and artistic common ground and an admiration for his work would have made Degas seem not only an attractive companion but also a social protector. Conversely, she was undoubtedly a forceful and determined personality who lived her life as she wished and not as social convention

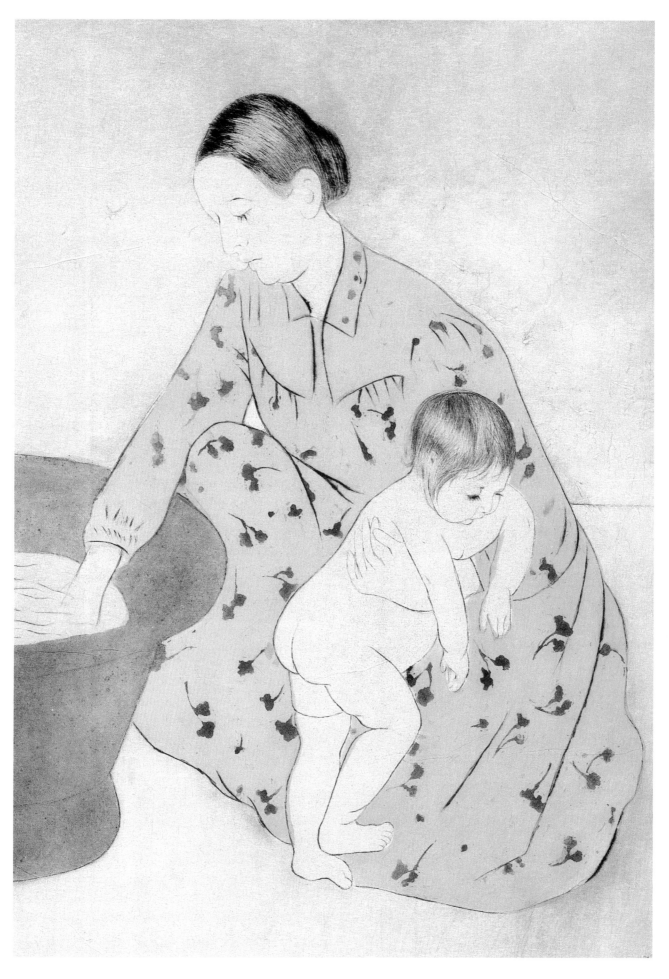

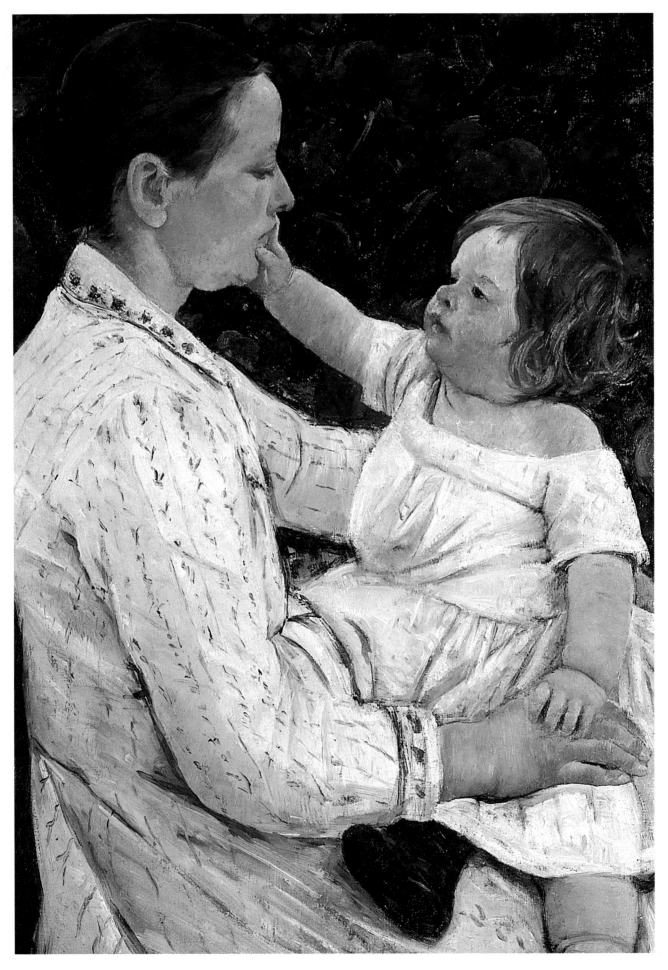

PLATE 32
The Child's Caress (c. 1890)
Oil on canvas, 26 x 21 inches (66 x 53.3cm)

The influence of Japanese prints entered Cassatt's oil painting and encouraged her to define forms which resulted in creating a feeling for solidity and precision, even defining form with line. In this painting the mother's full form and the child's pudgy body and head give a strong sense of realist vision rather than the

sentimentalist approach often attributed to Cassatt's work. There has been much speculation on the concentration that Cassatt focused on the theme of mother and child. It almost certainly reveals a yearning for children but also perhaps a recognition or belief in her own temperamental incapacity to become an effective mother. Imperious and self-absorbed, the choice of the subject may be an appropriate vicarious substitute. She was very much concerned with her family and her nieces and nephews as they grew up.

demanded. Intriguingly, she did destroy Degas' letters to her and she was against Degas' portrait of her (plate 16) being sold bearing her name. Could it be significant to this decision that she is holding photographs and looking 'pensive' or 'wistful'? Not much: but it leaves what seems likely to remain an open question. She is reported in old age, surprisingly, to have responded to an enquiry as to whether she had had an affair with Degas with: 'What! With that common little man? What a repulsive idea.' This seems unlikely to be true as Degas was certainly not a common little man and it is unlikely that Cassatt ever thought so. However, again, Degas was a mass of personality contradictions.

At all events, the relationship was strong and continuing. Another indication of the nature of their liaison is told by the painter Blanche of a dinner party at which conversation ranged over the state of the nation – and particularly politics. Degas was a dedicated nationalist and gained the acquiescence of the guests except Cassatt, whom he brusquely described as 'that independent American'. Although Cassatt loved France she was clearly no pushover. Cassatt helped Degas to sell his paintings to American acquaintances and introduced her friend Louisine Elder to Degas' work as well as that of other painters in Paris including Whistler and Pissarro. She was a good agent for her Impressionist friends and when Louisine married the rich industrialist Henry O.

Havemeyer, Cassatt helped them to amass a great collection of Impressionist and other paintings. (See plate 36.)

In 1890, Cassatt and Degas discovered together a new source of inspiration as the result of a visit to an important exhibition at the École des Beaux Arts in Paris of Japanese prints of the 18th and 19th centuries. These had been esteemed since the 1850s when they first arrived in France, used as wrapping paper for small cheap exports from Japan. Despite their often poor quality, they were admired for their dissimilarity from the art of the West with their different compositional devices, strong pattern and flat treatment. They had already had their effect on the work of a number of the independent painters, including Monet and Van Gogh, but this was an exhibition of high quality and they were both greatly influenced by its unfamiliar originality. For Degas, the compositional suggestions were the most attractive; for Cassatt it was the influence on her printmaking. She set up her own press to produce colour prints in the following year and some of these directly echo the designs of such Japanese printmakers as Utamaro and Toyokuni. Part of the closeness of their association was due to their mutual interest in printmaking and their passion for change and innovation.

By the last decade of the century, Cassatt had, like the other independents, achieved a solid reputation in France, exhibited regularly in the Salon and had completed a

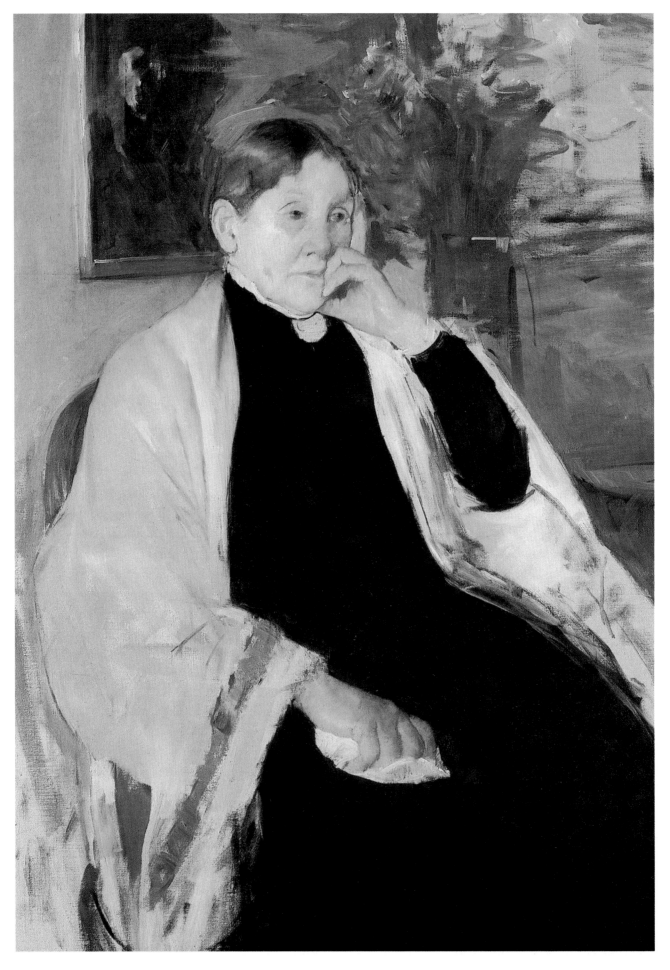

PLATE 33
Mrs Robert S. Cassatt: The Artist's Mother
(c. 1889)

Oil on canvas, 38 x 27 inches (96.5 x 68.6cm)

*Little more than a decade after she had painted her mother
reading* Le Figaro *(plate 12) in reading glasses and appearing
only middle-aged, Cassatt painted this portrait of her, now 73,*

*looking fixedly into the distance and appearing much older and
frailer. Although not in a finished form, it is a much more
formal work with restrained drawing and colour. The head is
treated in a more traditional technique than is usual with Cassatt
and it may be that she feared that time was against her and that
the opportunities for making such studies of her mother were
running out.*

number of portraits (none of which she allowed to be
sold). She was also continuing with her printmaking.

At this point her reputation spread to America. In
1893, the great World Columbia Exposition took place in
Chicago. All the notable American architects designed
buildings, including Louis Sullivan. The Women's
Building was designed by Sophia Hayden and Cassatt was
commissioned to paint a mural for the tympanum in the
Great Hall on the subject of 'Modern Women'. Like most
of the buildings and contents of the Exposition, the mural
was destroyed at the end of the great show but it is a
measure of her growing reputation that she had been
chosen, despite having spent most of her time and all her
working life abroad. In 1895 she had a show in New York
at Durand-Ruel's of paintings that had previously been
shown in his Paris gallery. Despite this show and her
reputation in Europe, when she returned after a period of
25 years, the local paper, the *Philadelphia Ledger*, reported:
'Mary Cassatt, sister of Mr. Cassatt, President of the
Pennsylvania Railroad, returned from Europe yesterday.
She has been studying painting in France and owns the
smallest Pekinese dog in the world.'

This quaint report did not, however, represent actual
public opinion in America. But it was not until the
Armory show in New York in February 1913 that
American understanding, appreciation or awareness of the
European artistic revolution which had commenced with

the Impressionists really began; a process that has led to the
United States' present regard for the arts both ancient and
modern. The importance of the International Exhibition
of Modern Art, now generally known as the Armory
Show because of its location within the 69th Regiment
Armory, can hardly be overstated. Among the work of
many contemporary 19th-century American painters, it
introduced most of the important European figures.
Somewhat surprisingly, one Delacroix and two Ingres
were included and towards the end of the 19th and
into the early part of the 20th century, such figures as
Cézanne (14 paintings), Gauguin (13 plus lithos), Van
Gogh (16), Manet (4), Monet (5), Renoir (5), Degas (3),
as well as Picasso (8), and Matisse (17) were represented.
Two paintings by Mary Cassatt were shown, both of
mothers with their children, one watercolour, one oil
(priced at $4,950).

The avant garde artists who had already seen her work
in Europe recognized her as a major figure of the
Impressionist revolution and placed her with their own
heroes from the early Hudson River School and Thomas
Cole to the late 19th-century painters such as Inness,
Whistler, Sargent, Homer, Eakins, Benton, Sloan and
others. For the public at large the show was a divisive
revolution; the academics derided, the young were
enthused. The show went from New York to Chicago and
thence to Boston. Everywhere it was a revelation and from

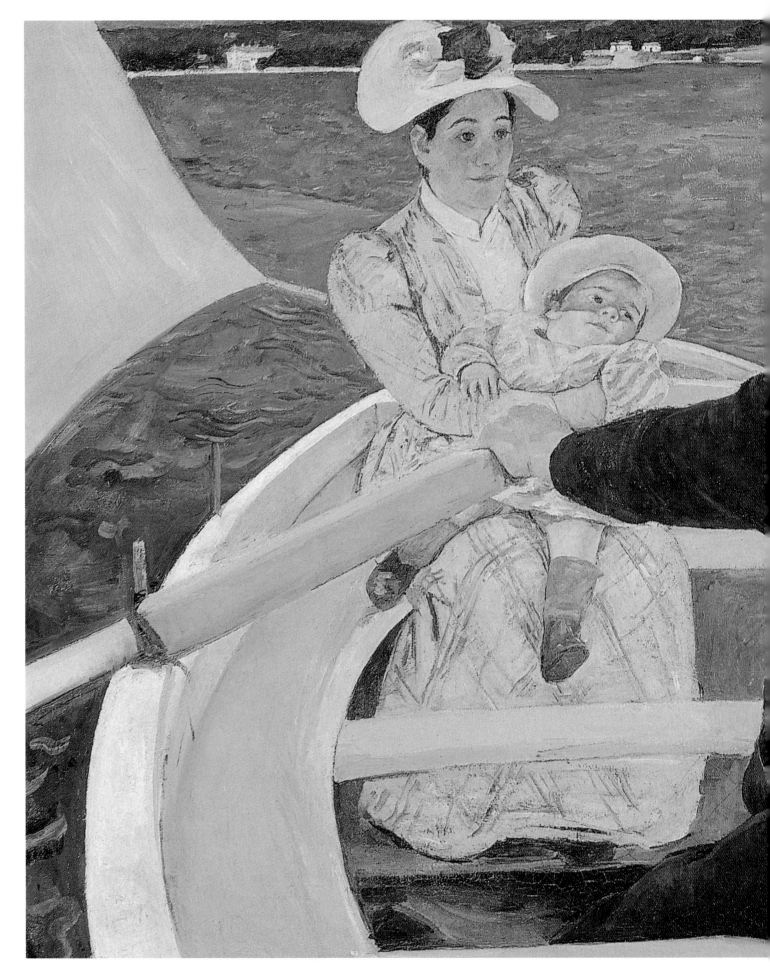

PLATE 34
The Boating Party (1894)
Oil on canvas, 35⁷/₁₆ x 46¹/₈ inches (90.2 x 117cm)

An unusual painting in the Cassatt oeuvre and one of her most ambitious compositions, this painting shows a number of influences. The Japanese print obviously influences the hard clear forms and the colour areas of definition, while the composition is part of the European tradition of drawing the viewer into the subject, which goes back at least to Caravaggio. The viewer is a passenger in the boat and sees the perspective steeply bent as the eye moves to the woman's head and the land horizon beyond. There are echoes of both Manet and Degas in the design. There is, however, a fixed static character to the work and one misses the lively freshness usually present.

PLATE 35
Summertime (c. 1894) detail
Oil on canvas, 29 x 38 inches (73.7 x 96.5cm)

Cassatt returned to this subject with variations and several times. It probably represents the pond behind her house, the Château de Beaufresne, near Beauvais during one summer early in the 1890s and is painted with a freedom and broadness that is not usually found in her work at this time. Compared with The Boating Party *(plate 34) with its tight, carefully defined form and strong simple-patterned colour, this painting, of which only a detail is shown, is sketched in thick, broadly drawn paint with remarkable freedom and directness. It is an unusually exuberant work for a 50-year-old socialite to have produced.*

this time, as Clemenceau said, 'the future is with the avant garde' in America. Cassatt's almost unique position in American painting was recognized.

Cassatt was never in that situation in which even successful painters frequently find themselves – short of money – and had never been. The independence this gave her was important in considering her life. Her career was the result of her own inner determination and its direction was decided by her; nothing restricted her. She became a professional painter because she wished it, unlike Degas who started as she did but was forced into a professional career at which he was very successful but always resented. This gave Cassatt leave to decide and control every aspect of her professional and personal life. The result was a dedicated, fiercely independent and single-minded woman. She was antagonistic to official art in France as her career there indicates and this attitude continued on her return to Philadelphia where she refused to submit to jury selection or even accept invitations to shows where there was any selection committee. She was also opposed to medals and awards, perpetuating the beliefs of the independents in France. It was incidentally the word 'independent' that she used rather than 'impressionist', in sympathy with Degas' rejection of the latter term. In consequence, in 1904, she declined an award of $300 from the Pennsylvania Academy of Fine Arts for a pastel of a mother and child. Perhaps the paltry sum may have had a bearing because in the same year she accepted the highest honour that France could bestow, the Légion d'Honneur, only the second in history to be awarded to a woman.

Cassatt's one last visit abroad when she was in France was to Egypt and the Near East, but her life during the latter years was occupied increasingly by an interest which turned into a passion for the feminist movement which was then under the leadership of Carrie Chapman Catt. In 1915 she exhibited with Degas at the Knoedler Gallery, New York in an exhibition in aid of the suffragettes. By now, however, she was experiencing bad health. She had a nervous breakdown and was diagnosed as having diabetes. To add to this, she developed cataracts which led to her partial blindness for the last decade of her life when she used an umbrella as a guide stick and still acted as imperiously as ever. She was sadly forced to relinquish printmaking and painting. She had numerous operations, the last in 1921, to no avail. On 14 June 1926, six months before Monet died and having outlived Degas by nearly ten years, she died at her home, the Château de Beaufresne at Mesnil-Théribus, near Beauvais in France, aged 82. She remains an important artist in a movement which has become the most widely loved and critically admired of all that we now called the modern movements in art – Impressionism.

That she made a significant contribution to the

Continued on page 64

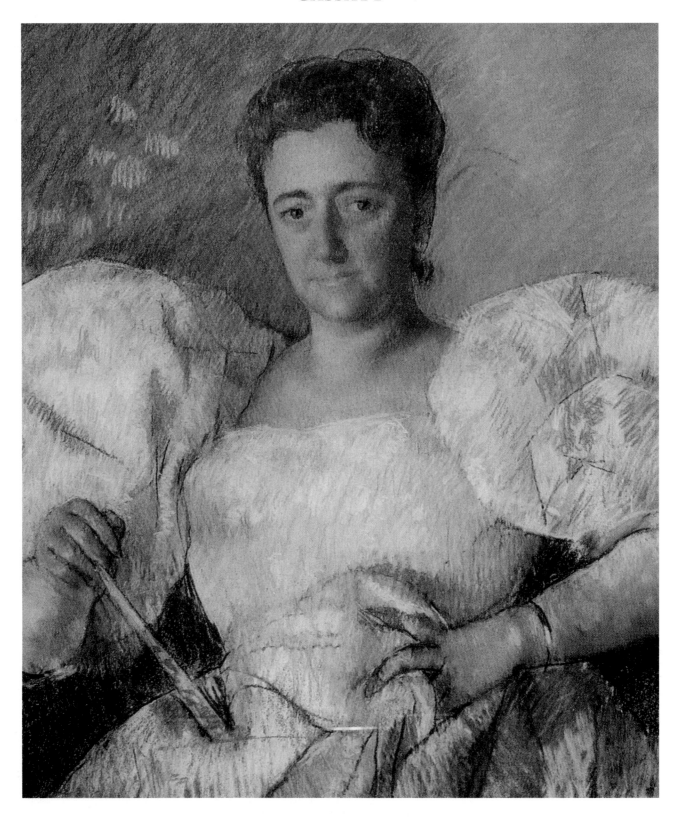

PLATE 36
Louisine Havemeyer (1896)
Pastel on paper, 29 x 24 inches (74 x 61cm)

Mrs Havemeyer became a close friend and colleague of Cassatt's after they met in Paris in 1874 and on her advice the Havemeyers

made an important collection of Impressionist and old master paintings. They were among the first Americans to introduce European painting to the United States. Cassatt was a good negotiator and bargain-hunter with a nose for a good deal and she acquired many paintings for Louisine at less than market value. As can be discerned, Mrs Havemeyer had a forceful personality.

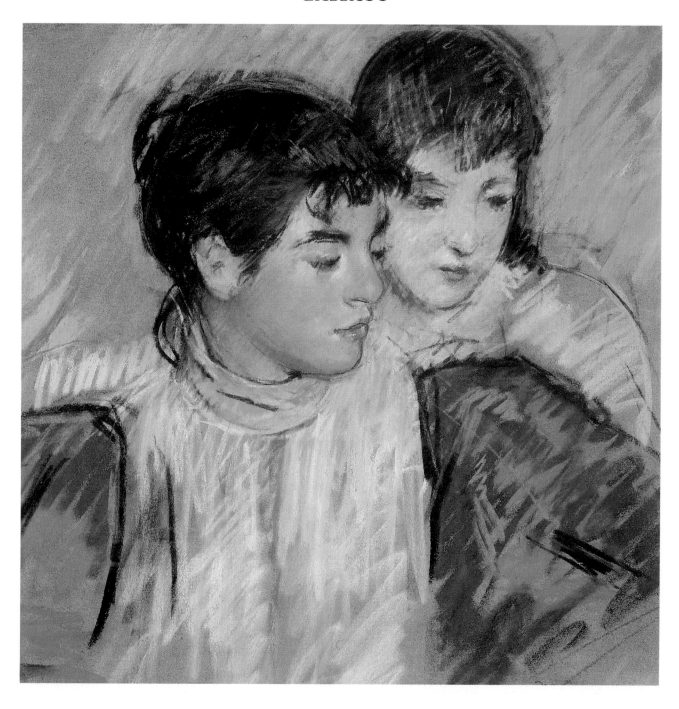

PLATE 37
Two Sisters (Study for The Banjo Lesson)
(c.1894)
Pastel on paper, 17 x 17 inches (43 x 43cm)

This brilliant sketch shows Cassatt's real skills as a draughtsman. The head of the nearer figure is sensitively drawn and delicately coloured and the volume of the head subtly expressed. The colour of the work is fresh and effective, the sharp blues, greens and yellows contrasting with the delicate pinks of the head.

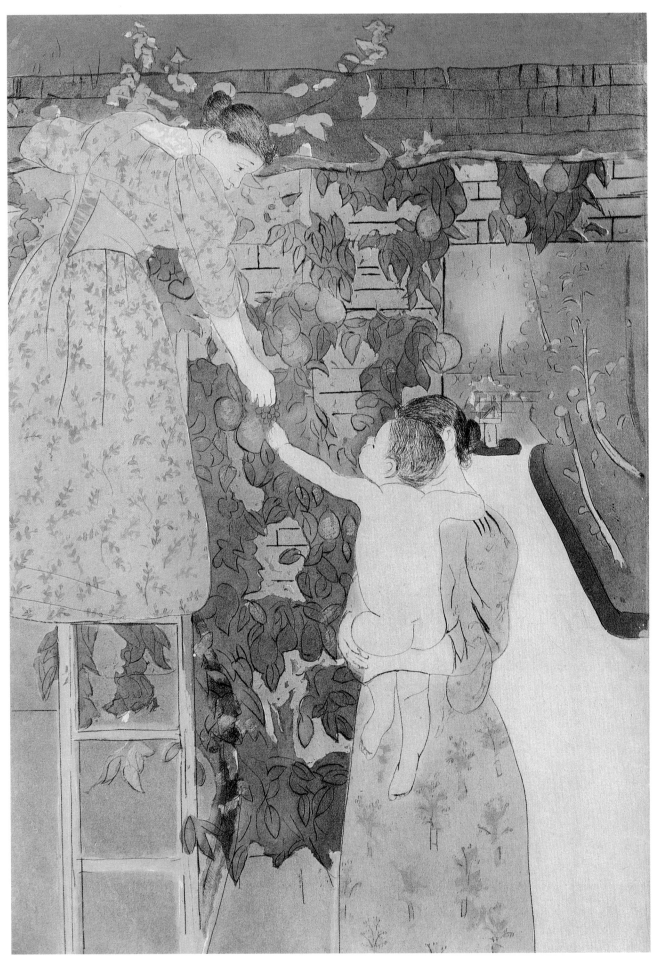

PLATE 38
Gathering Fruit (c. 1895) opposite
Drypoint and colour aquatint on paper,
16³/₄ x 11³/₄ inches (42.5 x 29.8)

*Another example of Cassatt's printmaking based on Japanese
models. (See also plates 26 and 27.)*

PLATE 39
Mother Playing with Her Child (1897)
Pastel on paper, 25¹/₂ x 31¹/₂ inches (64.5 x 80cm)

*The cool colours of the mother figure and the strong diagonal
gesture she makes towards her child contrasts effectively with the
rosy cheeks of the child and her mother. The concentration of both
on the hands emphasizes, as is usual with the Cassatt treatment
of this subject, the single centred concentration of both on the same
activity. There is the usual delicacy of drawing and sympathetic
delight in the subject in this attractive pastel.*

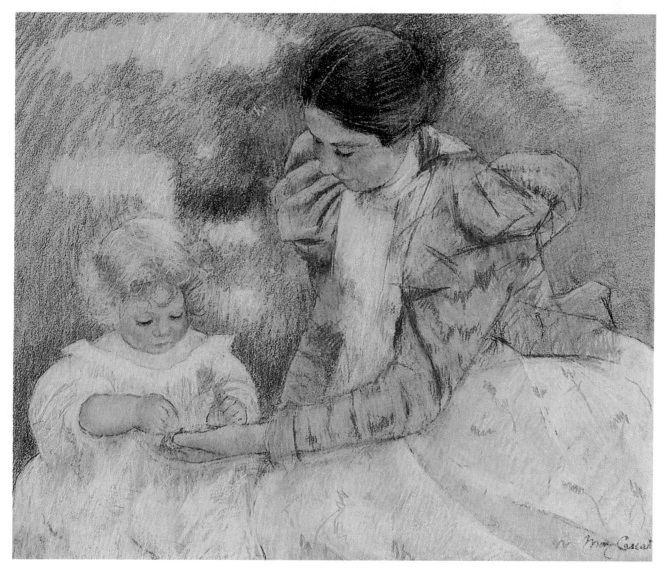

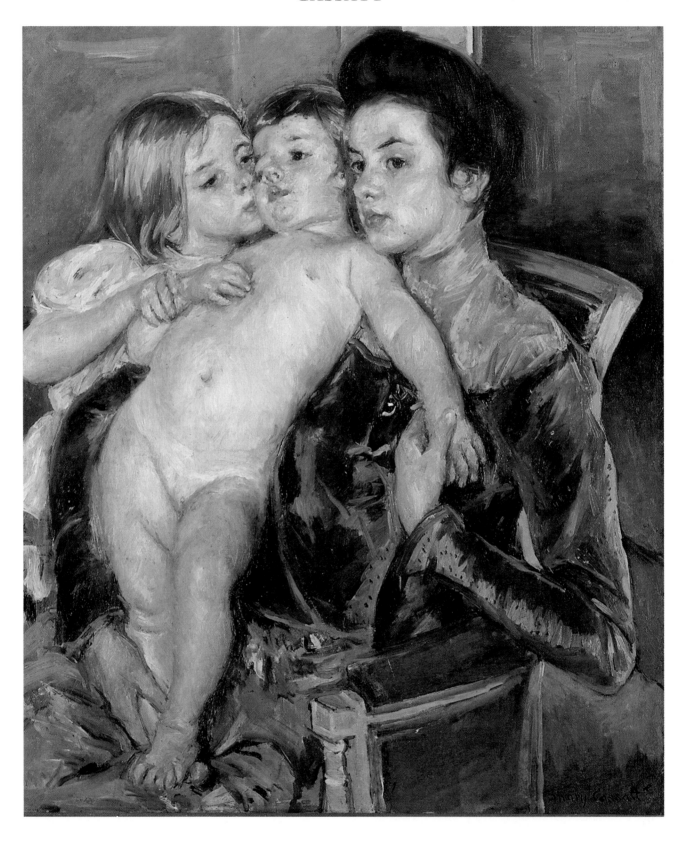

PLATE 40
The Caress (1902)
Oil on canvas, 32⁷/₈ x 27³/₈ inches (83.4 x 69.4cm)

The most unusual feature of this painting, although not unique in Cassatt's work, is the close juxtaposition of the heads and the emphasis on the pattern of the eyes. Most lines in the composition lead to this feature while the child is in a familiar pose adopted for the Christ figure in many Renaissance paintings. The blonde girl on the left, called Sara, appears in other paintings by Cassatt. It is another reminder that much of Cassatt's work was constructed through models and were not actual relationships.

PLATE 41
Nurse Reading to a Little Girl (1895)
Pastel on paper, 23³/₄ x 28⁷/₈ inches (60.3 x 73.3cm)

It seems likely that this pastel was made in the grounds of the Château de Beaufresne at Mesnil-Théribus, about 50 miles (80km) north of Paris, recently purchased by Cassatt as a result of her increasing popularity and sales. Most of her earlier works depicting an adult with a child were located in an enclosed space, often with an undefined background. Cassatt confessed that landscape did not deeply attract her and she had little wish to paint it (she thought little of Monet's painting) until she was located in the château in open countryside and with a spacious estate. Although the landscape is only sketchily indicated, there is nevertheless a strong feeling of an open sunlit scene.

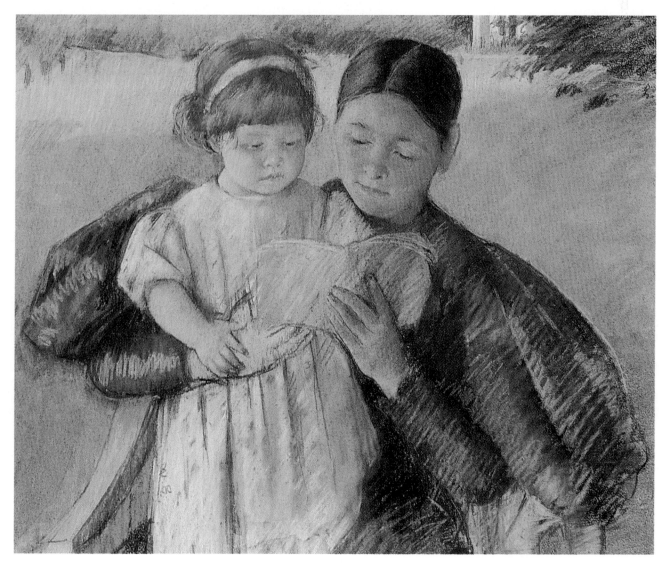

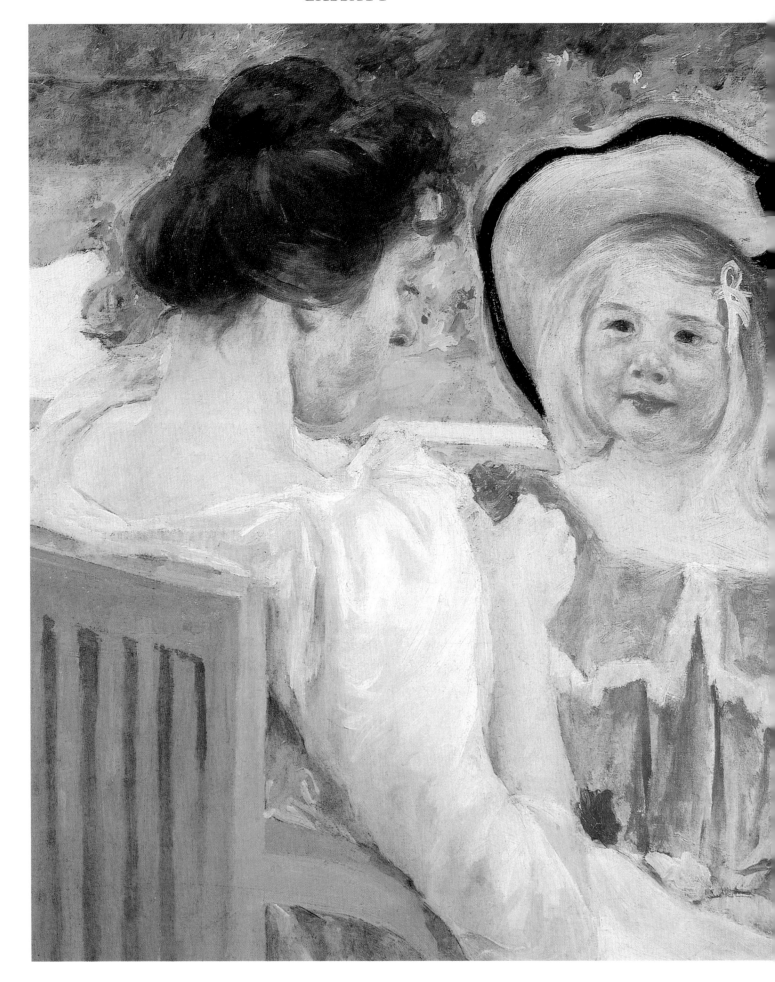

PLATE 42
In the Garden (1904)
Oil on canvas, 26³/₄ x 32¹/₂ inches (68 x 82.5cm)

This late painting shows Cassatt's continued fascination with the subject to which she had devoted much of her artistic endeavour. The mother and child theme is repeated here with the sitters somewhat older than usual. The intimacy of the scene is familiar and the observer in a participating position, able to engage in conversation. As usual, it is a constructed image, as evidenced by the fact that the child is the same model, Sara, who appears in plate 40. The treatment is less assured and the pattern more uncertain than is usual and this painting cannot be regarded as one of the artist's finest works.

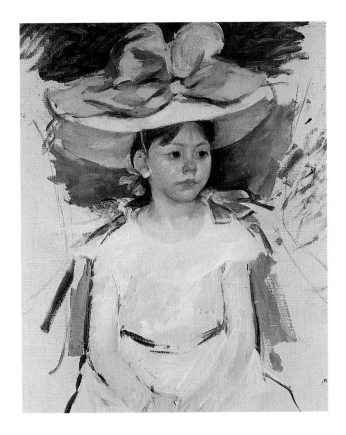

Continued from page 54

PLATE 43

Ellen Mary Cassatt in a Big Blue Hat

(c.1905)

Oil on canvas, 40¼ x 31½ inches (102 x 80cm)

This fresh and charming sketch of a member of Cassatt's family shows that her technique, when she was over 60, remained as adroit as it had ever been. The influence of Manet is more evident here than that of Degas. Although it is unfinished, the identification of the child's personality is sharply delineated.

PLATE 44

Mother and Child (1905) opposite

Oil on canvas, 36¼ x 29 inches (92 x 74cm)

movement is acknowledged, but since we have already described some of the difficulties in identifying what Impressionism was, analysing her work in relation to it poses the usual problems. Not exactly a chicken and egg situation but something akin to it. All art movements are visually defined by what their members produce and their attitudes towards it. Cassatt considered herself, like Degas, to be an independent. Much of the most clearly and acceptably identified Impressionists like Monet, Pissarro and Sisley were principally landscape painters and their most characteristic work was produced during the Argenteuil period and a little later. Cassatt was not part of this and was not attracted to landscape. She also thought Monet a poor painter. If her work is to be associated with any of the Impressionists it must be with Degas who never described himself or ever allowed himself, if he possibly could, to be described as an Impressionist, using either 'independent' or, preferably, 'realist'. In neither painter is the technique of short strokes and high-key colour characteristic. One of the supposed tenets of Impressionism is that black should be avoided. Neither Cassatt, Degas nor Renoir, an accepted Impressionist, avoided the use of black. There is much more that might be said of technical and aesthetic differences between the members of the Impressionist group; but the public steadfastly identifies them all as being caught in the same net, including Cassatt.

Her distinctive difference, as suggested earlier, lies not in technique or vision. It lies in involvement. Cassatt was attached to her limited subject-matter, the mother and child or child alone theme, with an emotional bond that is absent from Degas' paintings of nude women bathing or attending to their toilette. He appears to be neither sexually attracted nor involved, but a dispassionate observer of women who, although they are deliberately posed models, ostensibly do not realize they are being observed. With Cassatt, affection and regard leap out of the imagery. The themes of the love of a mother for her child or a child's joy at discovering life inspire her art. It is not an objective observation of effect. It is passionate and subjective. Although it would not have pleased her to hear it, there is something of the reverential in her Madonna and Child themes. True Impressionists would have regarded such feelings as academic and regressive.

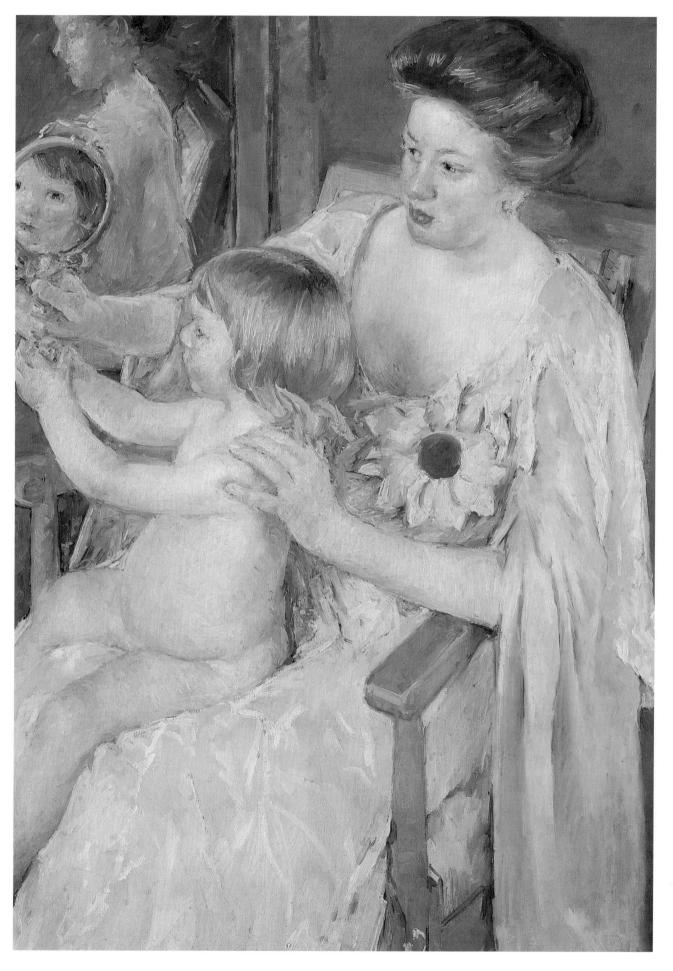

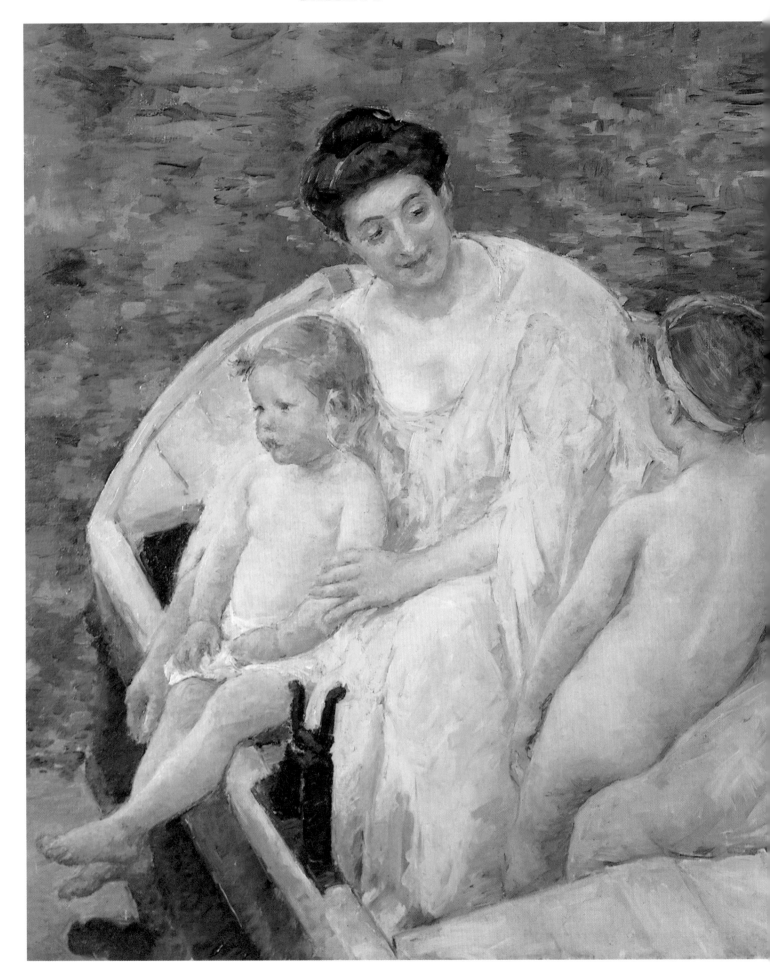

PLATE 45
The Bath (1910)
Oil on canvas, 38⁷/₈ x 50³/₄ inches (99 x 129cm)

*Painted when Cassatt was 74 and had retired to her beloved
Château de Beaufresne to enjoy a quiet and productive life in the
country, this painting is related to Summertime (plate 35),
which Cassatt set on the pond located behind the château. The
idyllic sunlit calm prompted a work of sheer delight. Yet again
reminiscent of Degas, the artist has set the observer in the middle
of the scene, apparently standing on the stern boards of the rowing
boat and looking down at his or her companions with pleasure.
The angle of the perspective effectively creates an intimate scene
and is painted with a tender concern. Models were probably used
for all the figures and the child with her feet over the side of the
boat looks much like the familiar Sara. The paint quality does
not perhaps have the assurance of earlier years but the pleasure of
a peaceful summer outing pervades the scene.*

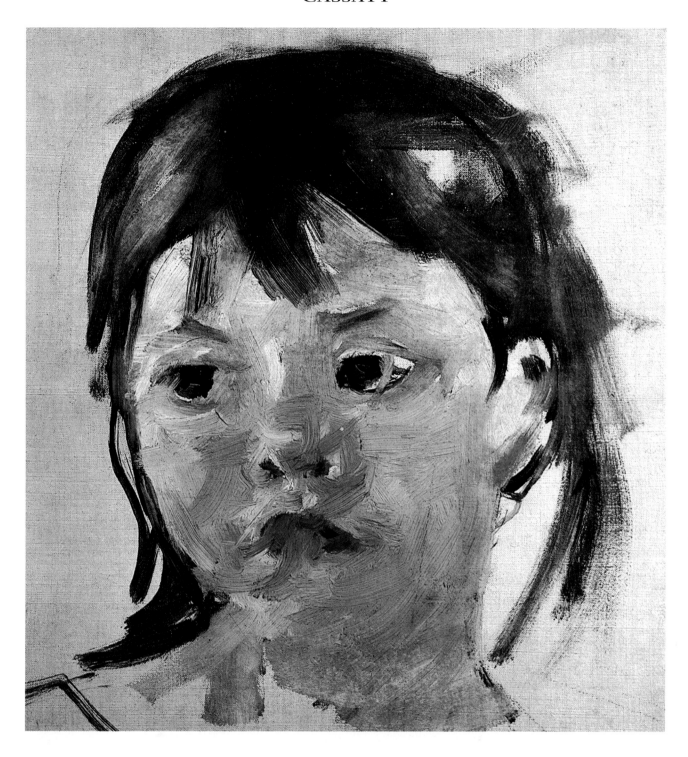

PLATE 46
Mother and Child (c. 1900)
Pastel, 31½ x 23¼ inches (80 x 59cm)

This unfinished pastel concentrates on the heads of the two figures which, in this instance, are unusually not preoccupied with one another but are engaged in separate concerns. The mother is sewing and the child is looking at something outside the picture while casually leaning on her mother's knee.

PLATE 47
Head of a Little Girl (date unknown)
Sketch in oils

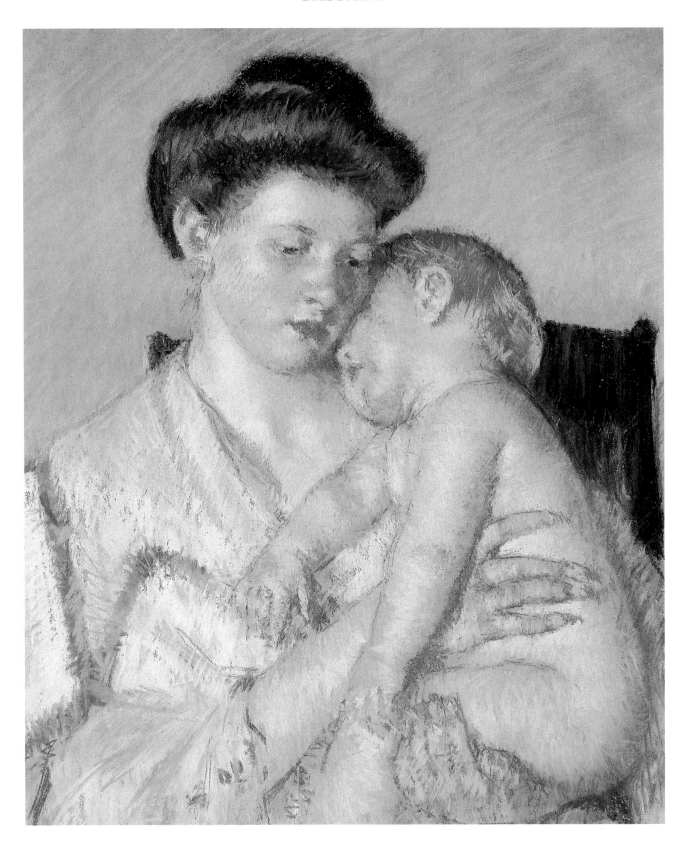

PLATE 48
Sleepy Baby (c. 1910) detail
Pastel on paper, 25$\frac{1}{2}$ x 20$\frac{1}{2}$ inches (64.5 x 52cm)

The delicacy of drawing and careful draughtsmanship, together with the contrasting colour patterns of pinks and blues, make this

an unusual late work. It still shows an undiminished interest in representing mother-love and filial security and the drawing of the heads and hands is still acutely observed.

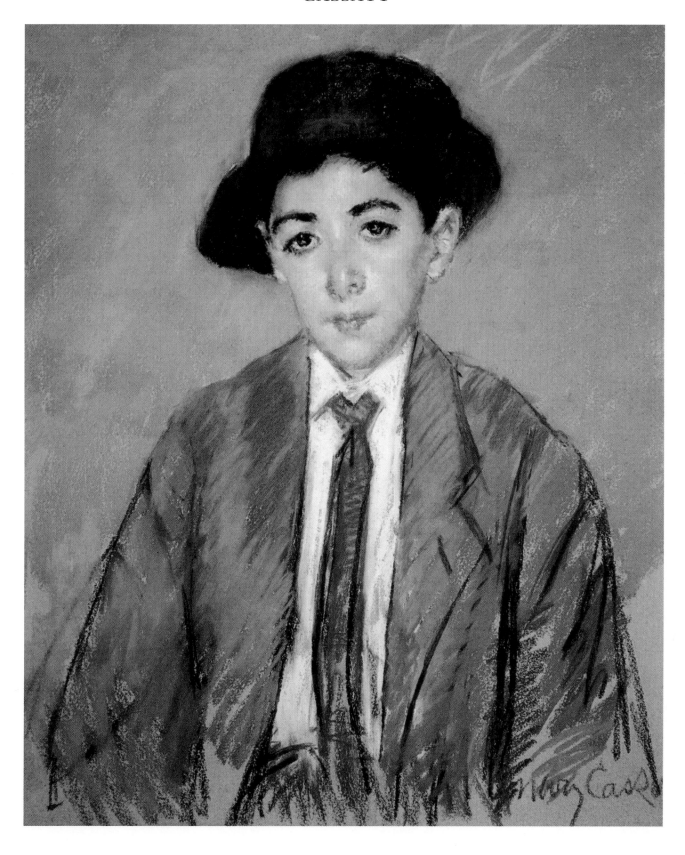

PLATE 49
**Portrait of Charles Dikran Kelekian,
Aged 12** (1910)
Pastel on paper, 36¹/₂ x 21¹/₈ inches (92.7 x 53.6cm)

*Although it is not apparent in this pastel, Cassatt was already
beginning to suffer from cataracts which after 1912 prevented her
from continuing to work. The drawing is nevertheless forthright
and strong and the colour is well suited to the young male sitter.*

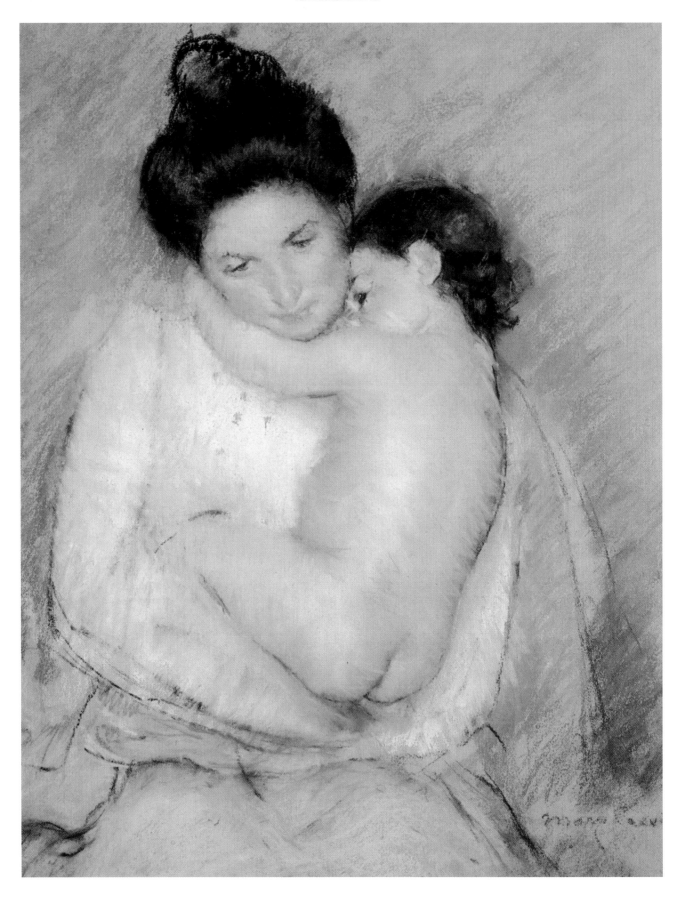

PLATE 50
Mother and Child (undated)
Pastel on paper, 28 x 23 inches (71 x 58.4cm)

PLATE 51

Young Child in Its Mother's Arms Looking at Her with Intensity (1910)

Oil on canvas, 17³/₄ x 14¹/₄ inches (45 x 36cm)

A further example of a preparatory sketch, unsigned, for a painting of Cassatt's most favoured subject to which she returned throughout her career. There are a number of finished works for which this may be a study.

PLATE 52
Head of a Child (date unknown)
Pastel

*In the happy world of Cassatt's mother and child paintings this
work is something of a surprise. It is a finished painting rather
than a study of a not only unhappy but possibly disagreeable
child whose pouting mouth and fiercely concentrated eyes seem
alien to Cassatt's normal choice and treatment of her subject.*

PLATE 53
Mother and Child (1897)
Pastel on cardboard, 20⁷/₈ x 17³/₄ inches (53 x 45cm)

A charming pastel drawing of a familiar subject treated in Cassatt's usual intimate compositional form. As mentioned earlier, she finds an attraction in linking the two figures with a linear eye relationship repeated in this work.

ACKNOWLEDGEMENT

The Publishers wish to thank the following for providing photographs, and for permission to reproduce copyright material. While every effort has been made to trace and acknowledge copyright-holders, we wish to apologize should any omissions have been made.

Offering the *Panal* to the Toreador
Sterling and Francine Clark Art Institute, Williamstown

Mary Ellison Embroidering
Philadelphia Museum of Art: Gift of Jena Thompson Thayer

Two Women Seated by a Woodland Stream
Private Collection, U.S.A.

On the Balcony, During the Carnival
Philadelphia Museum of Art, PA: W.P. Wilstach Collection

A Musical Party
Musée du Petit-Palais/Giraudon, Paris

Mary Ellison
National Gallery of Art, Washington, DC

Self-Portrait
Metropolitan Museum of Art, New York

Little Girl in a Blue Armchair
© 1998 Board of Trustees, National Gallery of Art, Washington, DC

Portrait of Moïse Dreyfus
Musée du Petit-Palais

Woman Reading *Le Figaro*
Christie's London/Bridgeman/Giraudon, Paris

La Loge
Philadelphia Museum of Art, PA

Self-Portrait
Art Resource/Giraudon, Paris

Portrait of a Young Woman in Black
The Peabody Institute of the City of Baltimore, on extended loan to the Baltimore Museum of Art, MD

Edgar Degas' Portrait of Mary Cassatt
Morris and Gwendolyn Cafritz Foundation and the Regents Major Aquisition Fund, National Portrait Gallery, The Smithsonian Institution, Washington, DC

Portrait of Lydia Cassatt
Musée du Petit-Palais/Giraudon, Paris

Lady at the Tea Table
Metropolitan Museum of Art, New York, NY

Alexander Cassatt and His Son Robert
Philadelphia Museum of Art, PA: W.P. Wilstach Collection

Young Woman Sewing
Musée d'Orsay/Giraudon, Paris

Girl Arranging Her Hair
© 1998 Board of Trustees, National Gallery of Art, Washington, DC

Child in a Straw Hat
Collection of Mr. and Mrs. Paul Mellon, National Gallery of Art, Washington, DC

Hélène de Septeuil
Louise Crombie Beach Memorial Collection, The William Benton Museum of Art, The University of Connecticut, Storrs, CT

Young Woman at the Window
Musée d'Orsay, Paris

Mother Combing Her Child's Hair
The Brooklyn Museum, New York, Bequest of Mary T. Cockcroft

The Letter
National Gallery of Canada, Ottawa

The Bath
Gift of Paul J. Sachs, 1916, Metropolitan Museum of Art, New York

Baby's First Caress
Harriet Russell Stanley Fund, from the collection of the New Britain Museum of American Art, CT

The Fitting
Chester Dale Collection, © 1998 Board of Trustees, National Gallery of Art, Washington, DC

Mother's Kiss
© 1998 Board of Trustees, National Gallery of Art, Washington, DC

The Bath (The Child's Bath)
Rosenwald Collection, National Gallery of Art, Washington, DC

The Child's Caress
Memory of Wilhemina Tenney, 1953, Honolulu Academy of Arts

Mrs Robert S. Cassatt: The Artist's Mother
Museum Purchase, William H. Noble Bequest Fund, The Fine Arts Museum of San Francisco

The Boating Party
Chester Dale Collection, © 1998 Board of Trustees, National Gallery of Art, Washington, DC

Summertime
Terra Foundation for the Arts, Daniel J. Terra Collection, Terra Museum of American Art, Chicago, IL

Louisine Havemeyer
Courtesy of Shelburne Museum, VT

Two Sisters (Study for the Banjo Lesson)
The Hayden Collection. Courtesy Museum of Fine Arts, Boston

Gathering Fruit
Metropolitan Museum of Art, New York

Mother Playing with Her Child
Dr. Ernest Stillman, 1922, from the collection of James Stillman, the Metropolitan Museum of Art, New York

The Caress
Art Resource/Giraudon, Paris

Nurse Reading to a Little Girl
Gift of Mrs. Hope Williams Read, 1962, Metropolitan Museum of Art, New York

In the Garden
Gift of Dr. Ernest Stillman, © The Detroit Institute of Arts, MI

Ellen Mary Cassatt in a Big Blue Hat
Collection of Dr. Herchel Smith, 1977, Courtesy of the Williams College Museum of Art, Williams College, Williamstown, MA

Mother and Child
Chester Dale Collection, © 1998 Board of Trustees, National Gallery of Art, Washington, DC

The Bath
Musée du Petit-Palais/Art Resource/Giraudon, Paris

Mother and Child
Private collection, Paris

Head of a Little Girl
Private collection

Sleepy Baby
Munger Fund, Dallas Museum of Art, TX

Portrait of Charles Dikran Kelekian, Aged 12
Bequest of Beatrice A. Kelekian in Memory of Mr. and Mrs. Charles D. Kelekian, The Walters Art Gallery, Baltimore, MD

Mother and Child
© 1998 The Art Institute of Chicago, IL

Young Child in Its Mother's Arms Looking at Her with Intensity
Roy Maurcourt, private collection/Giraudon, Paris

Head of a Child
U.S.A./Giraudon, Paris

Mother and Child
Musée d'Orsay/Giraudon, Paris

DATE DUE

DATE DUE			

759.13
COP Copplestone, Trewin
 Mary Cassatt

Westfield Middle School

Westfield Middle School
Media Center